BADASS GODDESS

by

Cassandra Bodhi
&
Lacy Bloom

Warning:

You are about to enter the world of the impertinent, the world where what has been said while you're coloring, can't be unsaid. It's a sassy world, but one mixed with inspiration, courage, and love. So, get ready for some sweary art and pour yourself some wine, because you're about enjoy this amazing coloring book.

Welcome to BADASS GODDESS.

Here, children are not allowed, as this book is filled with colorful adult language.

What you will find in the ensuing pages are phrases and mandalas that fit the personality of each Goddess you're about to encounter. Tread lightly and listen to these Goddesses, for they are here to help you. Sometimes they will forcefully push you where you need to go, and other times they will lend you a hand and gently caress you in a loving embrace. Most importantly, it's all in the name of compassion and grace.

Copyright © 2016
Cassandra Bodhi and Lacy Bloom

All Rights Reserved

ISBN: 1540404153
ISBN-13: 978-1540404152

The Lacy Bloom and Cassandra Bodhi Team of Artists

Oancea Camelia
Brandon Ellis – www.lacybloom.com
Shaily
Nisha Dissanayake
Amy Sunlover - https://www.instagram.com/amysunluvr/
Harriet Rodis - http://harrietrodis.weebly.com/
Rumi Das
Nadia Campos Avila

DEDICATION:

Lacy Bloom – To Jenna Ellis and Lilyana Sage Ellis-Hartley, my daughters.

Cassandra Bodhi – To Caitlin McCulloch, my daughter.

BadAss Goddesses – To all those who wish to seek a better world with peace and understanding, which is where love and gratitude can always be found. Now let's get this fucking show on the road!

SPECIAL BONUS:

DOWNLOAD MY PDF VERSION OF "ENLIGHTEN THE FUCK UP"

It's an Inspirational Swear Word Coloring Book for Adults.

And, it's a gift to you for purchasing my book.

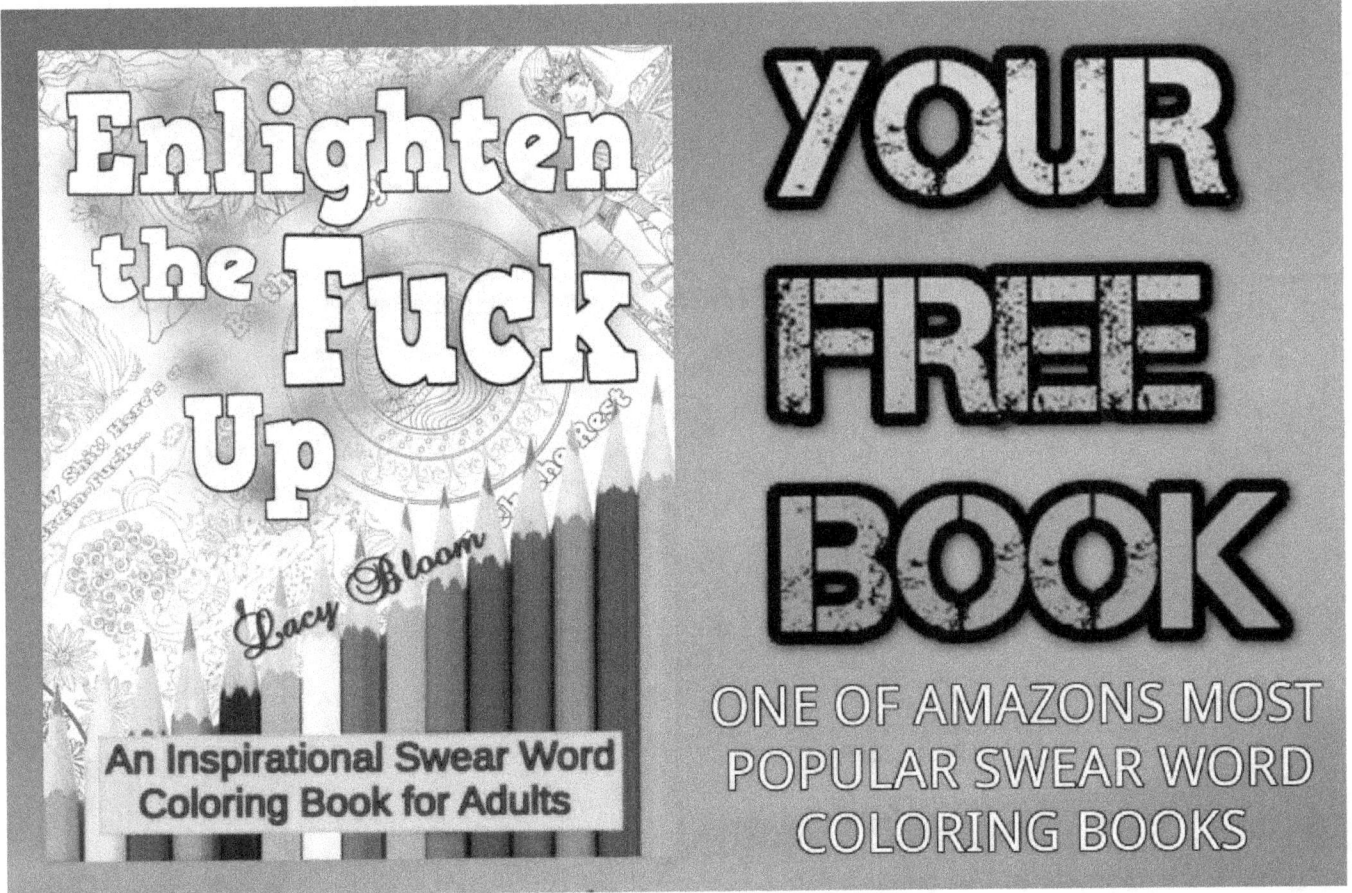

GO TO: www.lacybloom.com

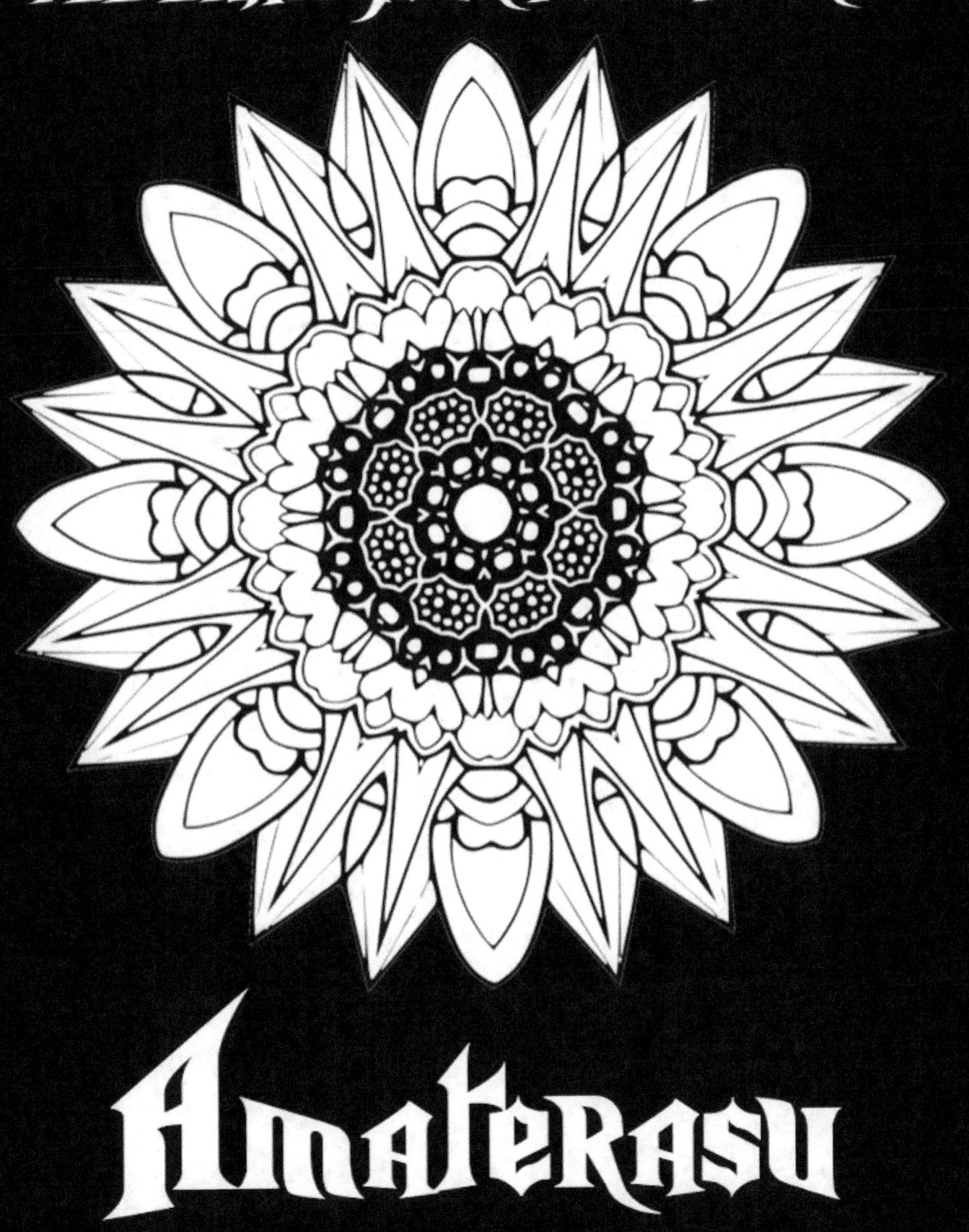

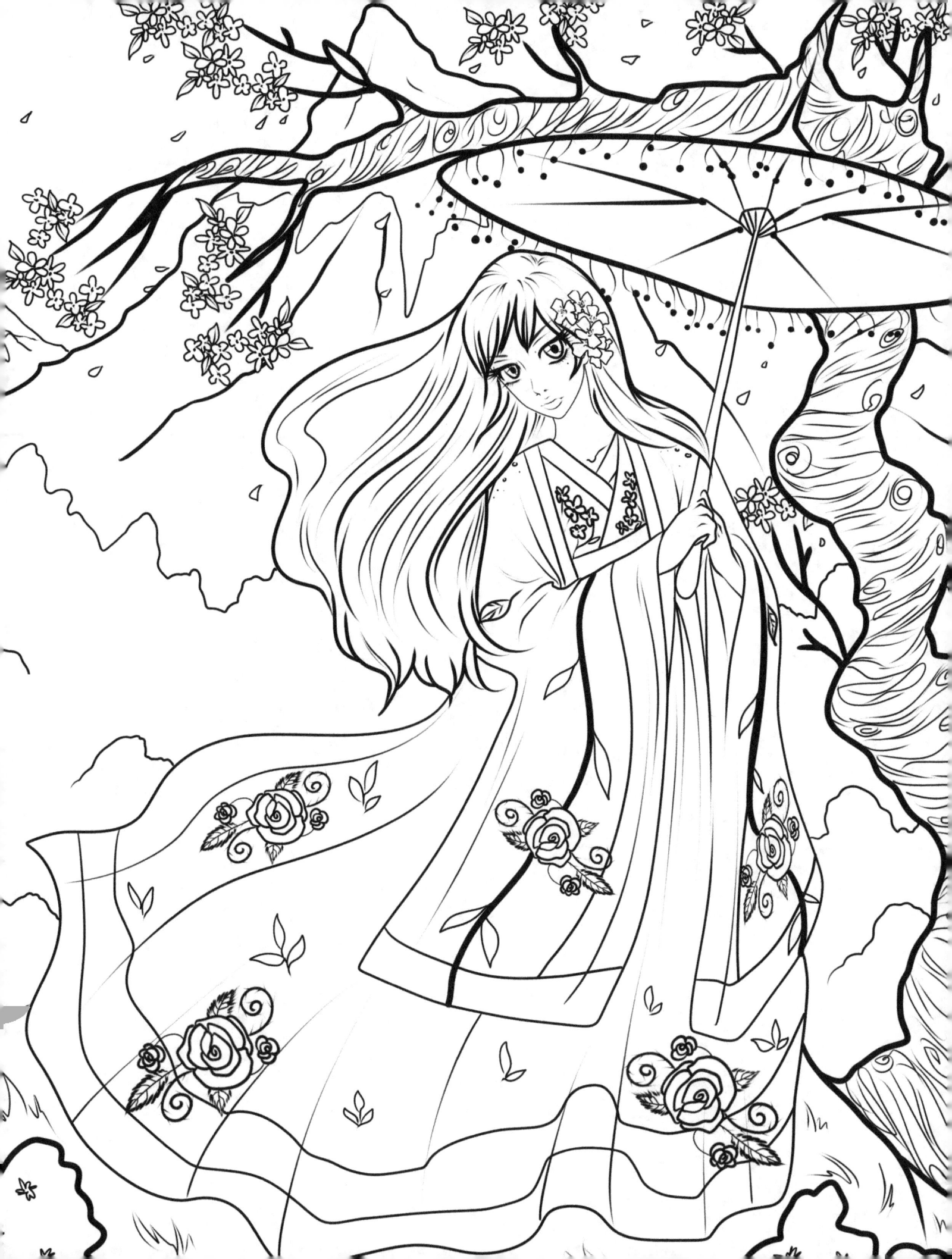

Aphrodite

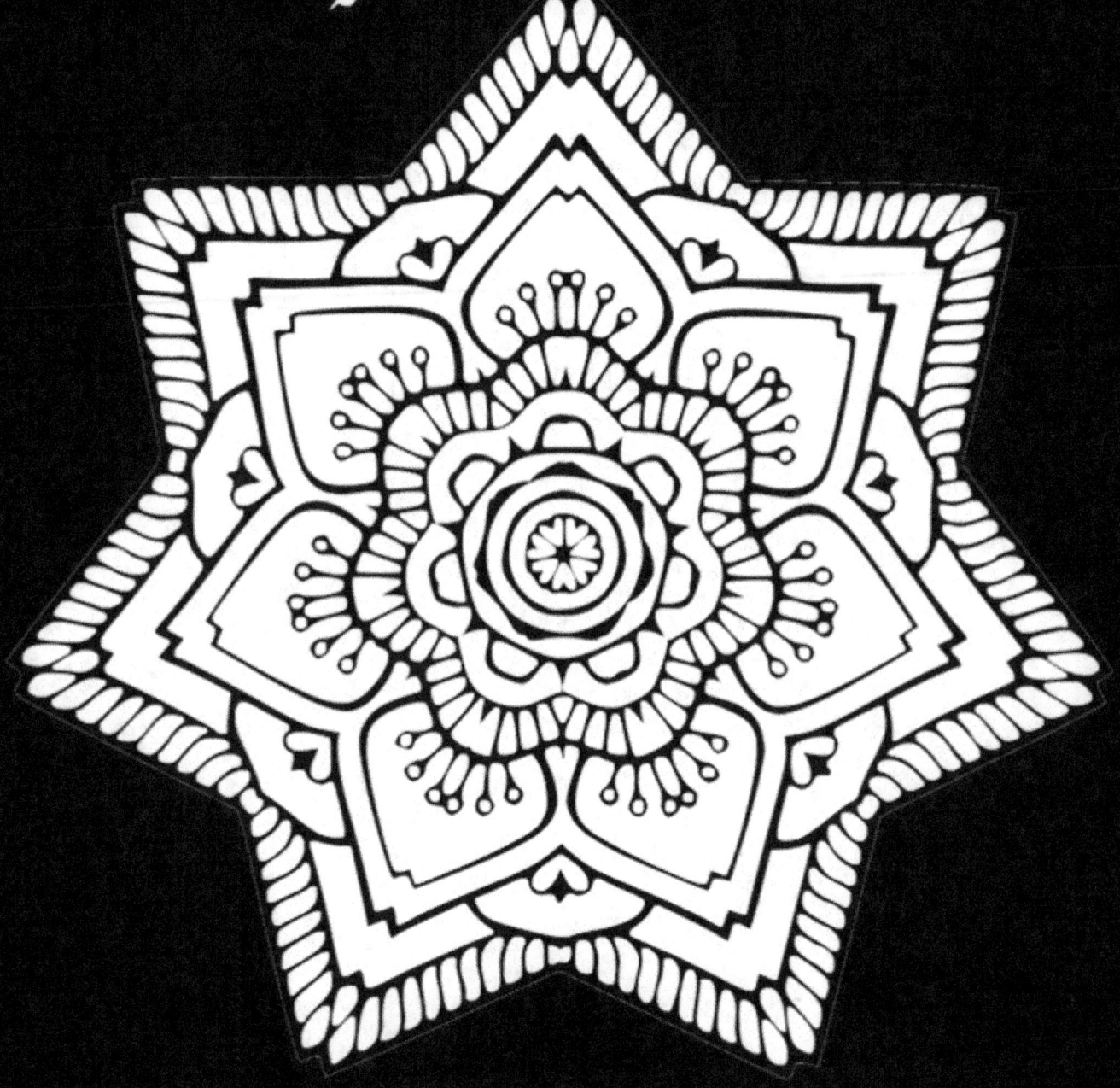

Go and grab the world like a fucking storm. Never shy away, for this is your life, not anyone else's. I'm always there guiding you with love.

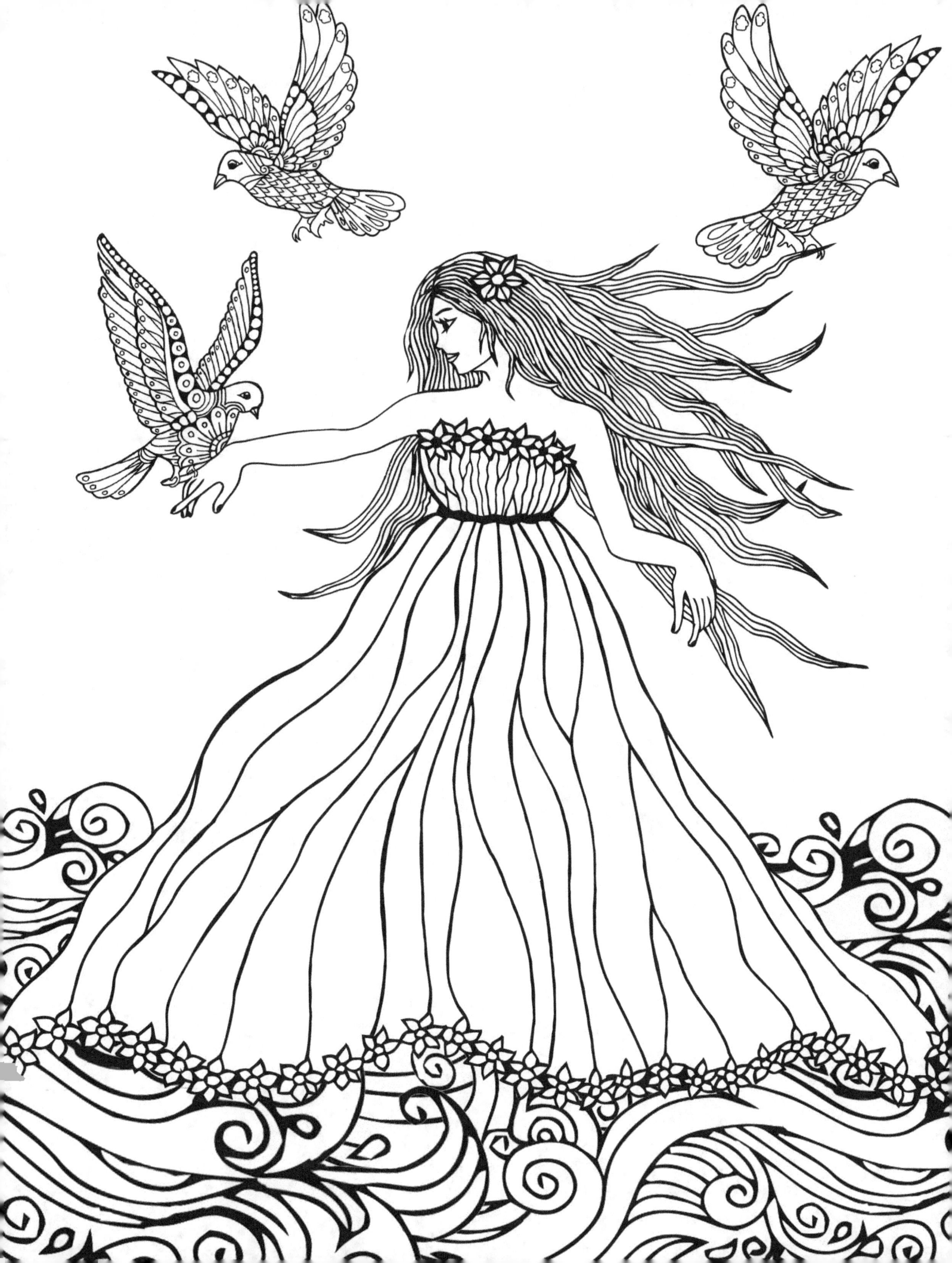

BAST YOU KNOW MY PROTECTIVE WILD CAT POWER CAN BRING A SHIT STORM UPON THOSE WHO CAUSE YOU ILL!

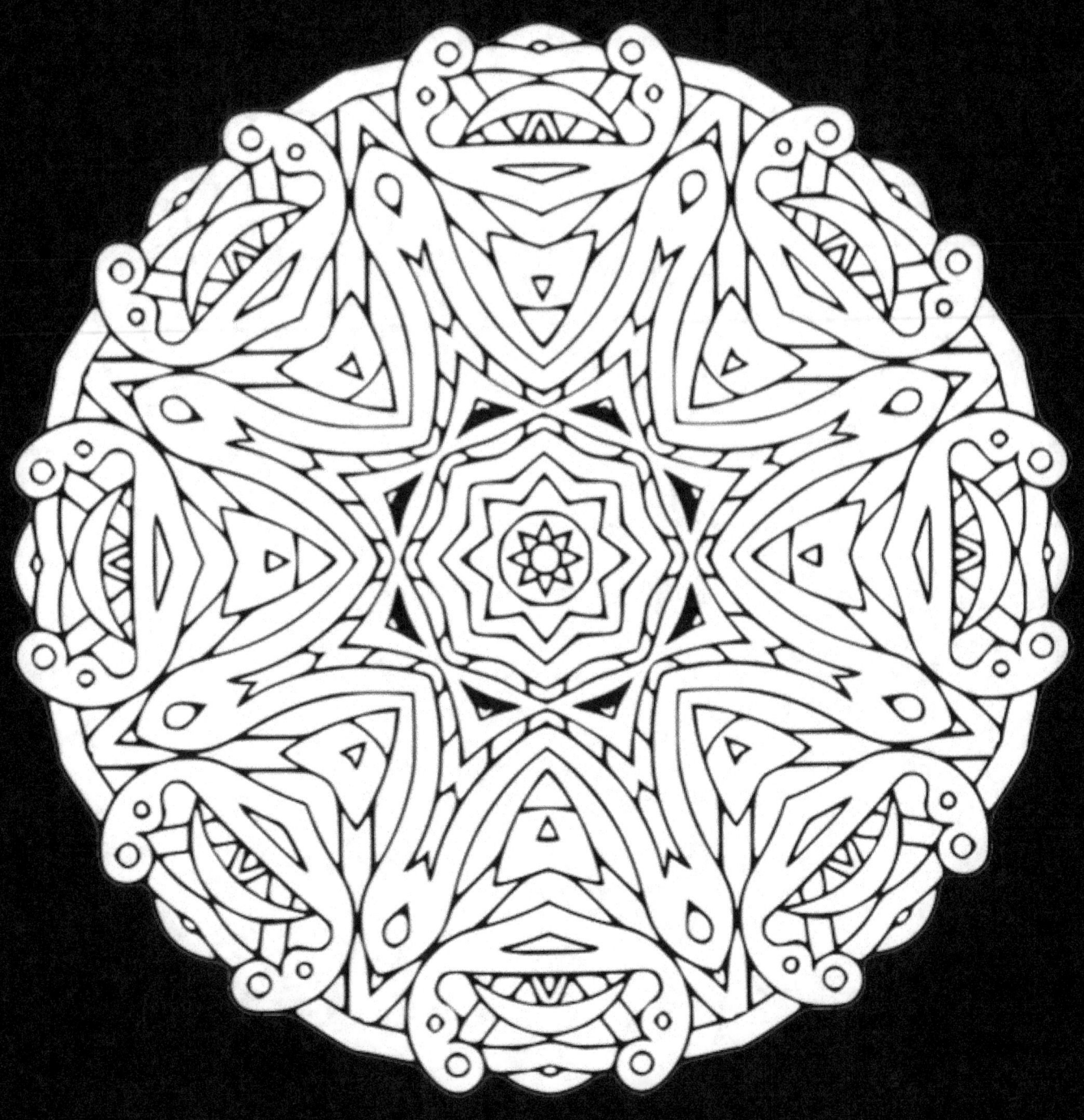

BAST

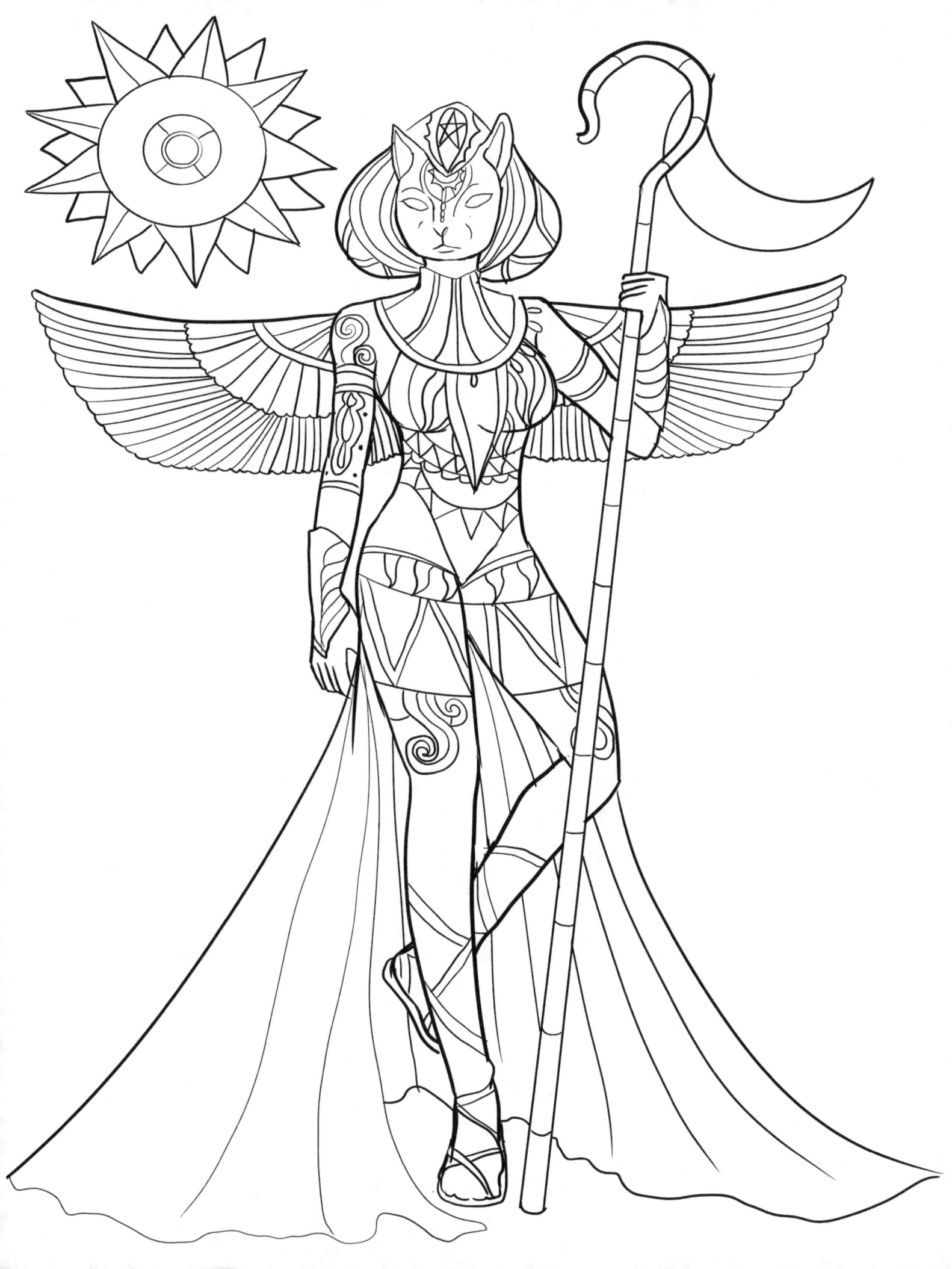

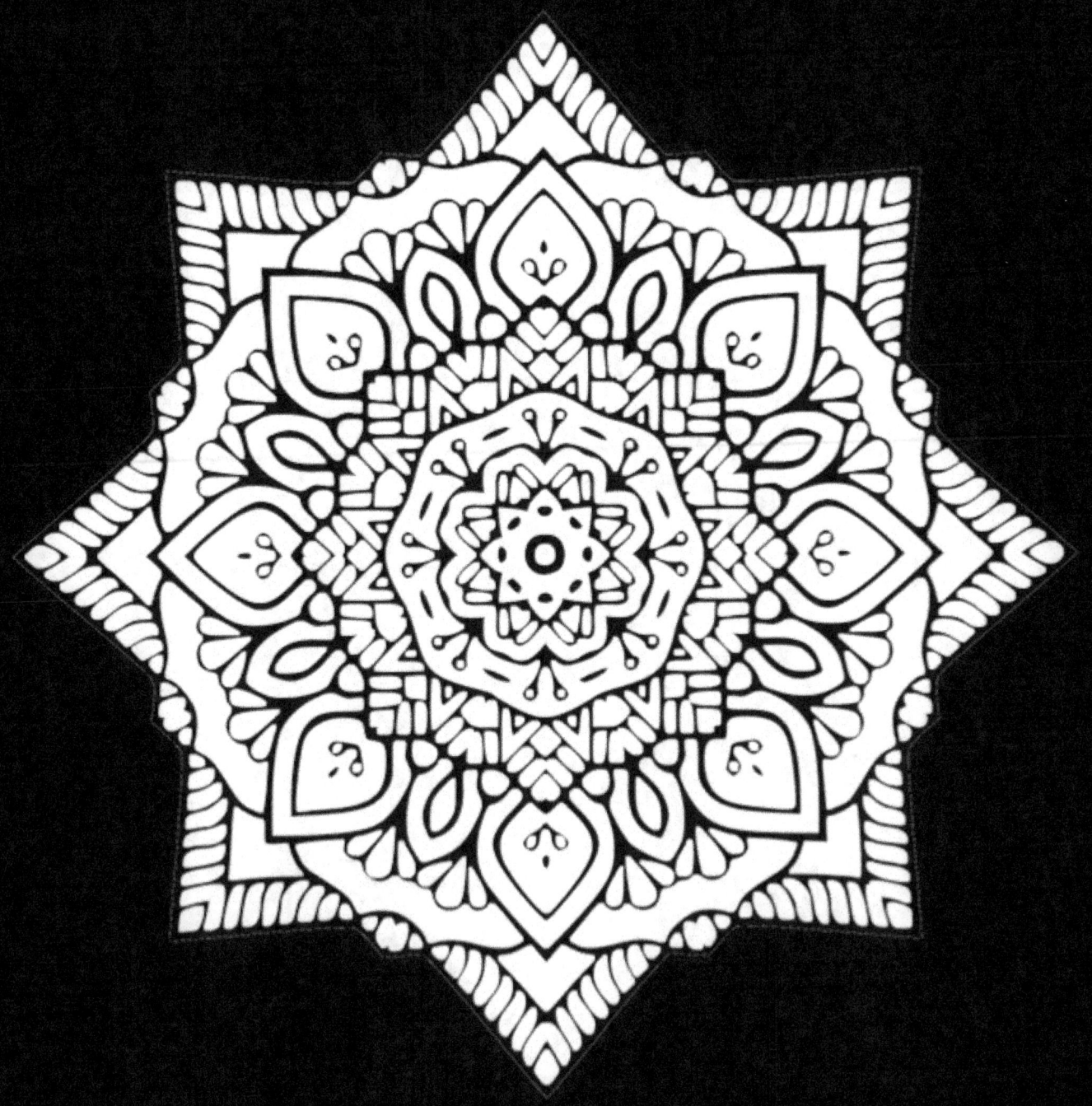

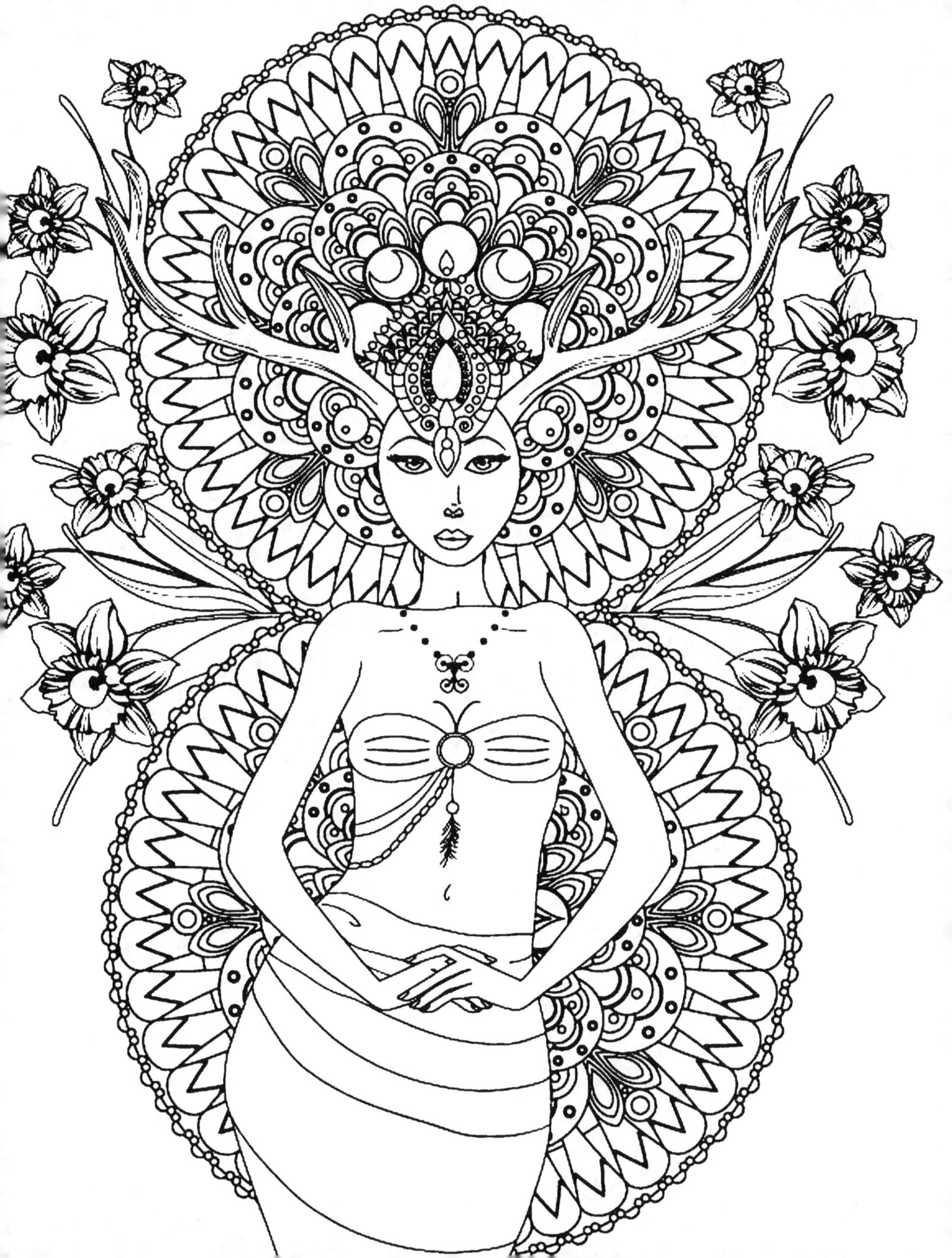

Death of perception isn't the end, it's transformation and new beginnings. Change is a must, embrace it. Fucking express yourself!

EAGLE WOMAN

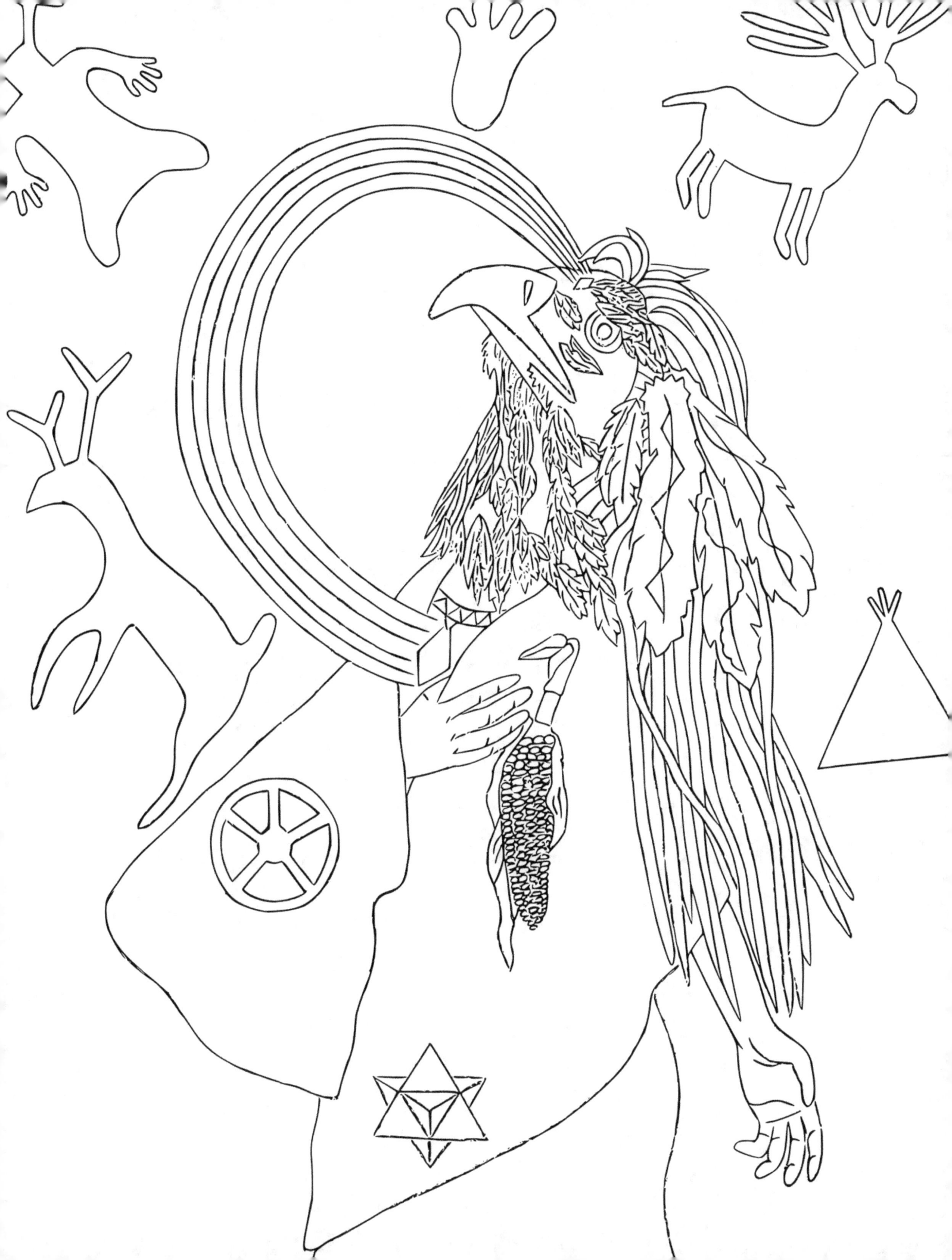

GAIA

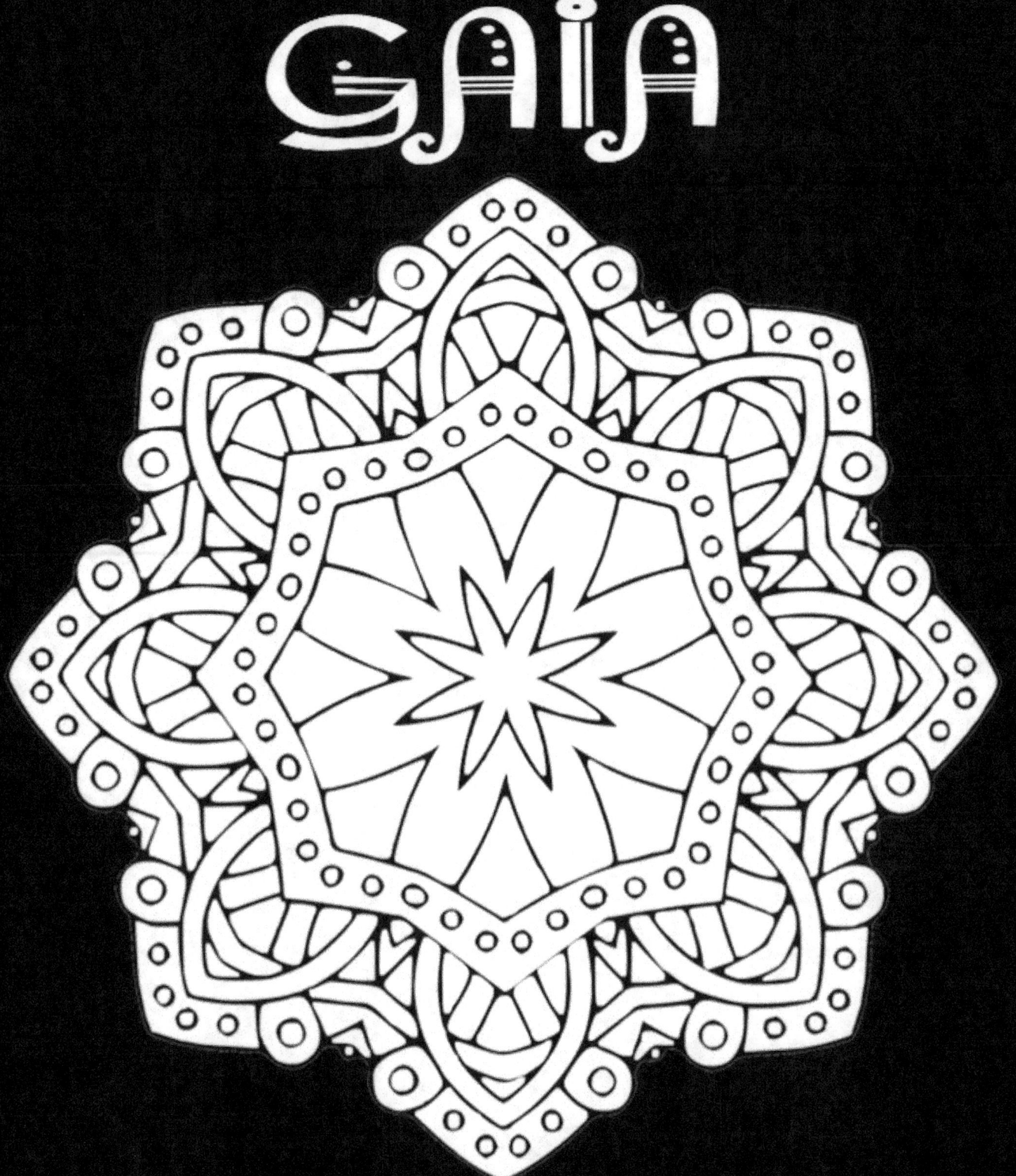

Respect what I give for I ask you nothing in return. Remember I brought you into this world and I can take you out of it like a bad ass goddess.

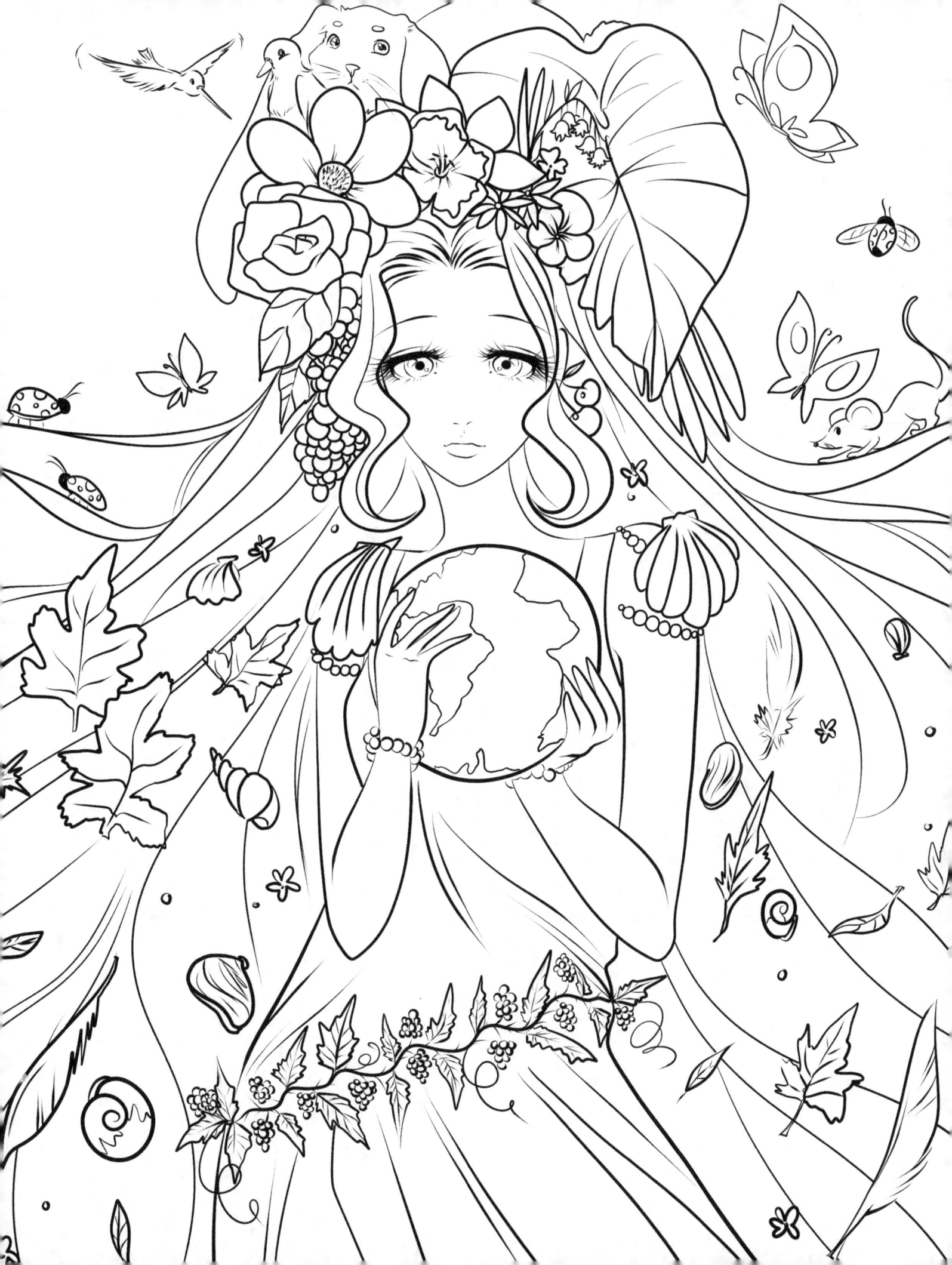

Manifest, my friend. Unleash your creative side and discover your true potential. This is bravery. Let the cynical bastards stir in their own critique. It's time for you to thrive, not just survive.

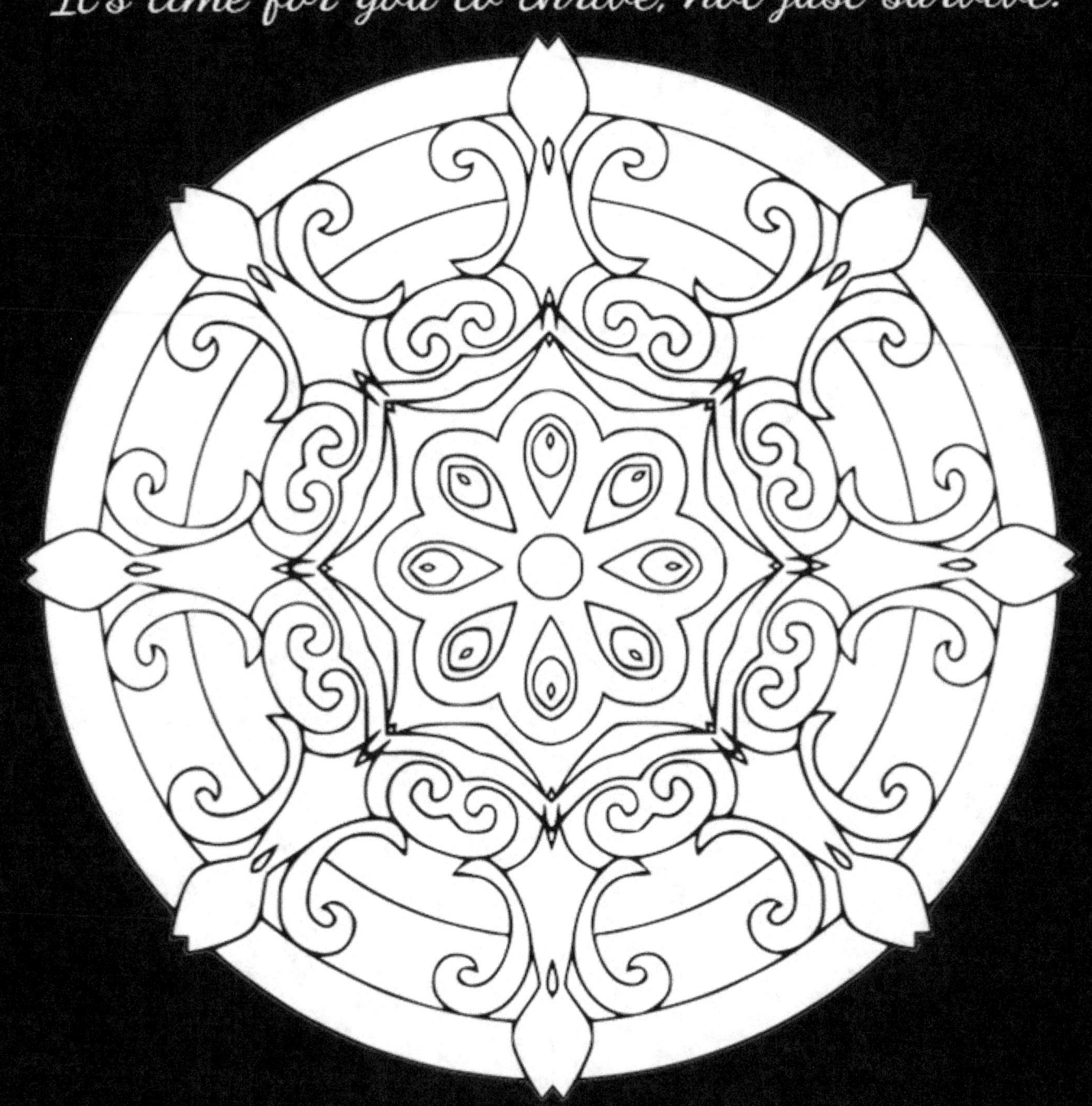

HENA

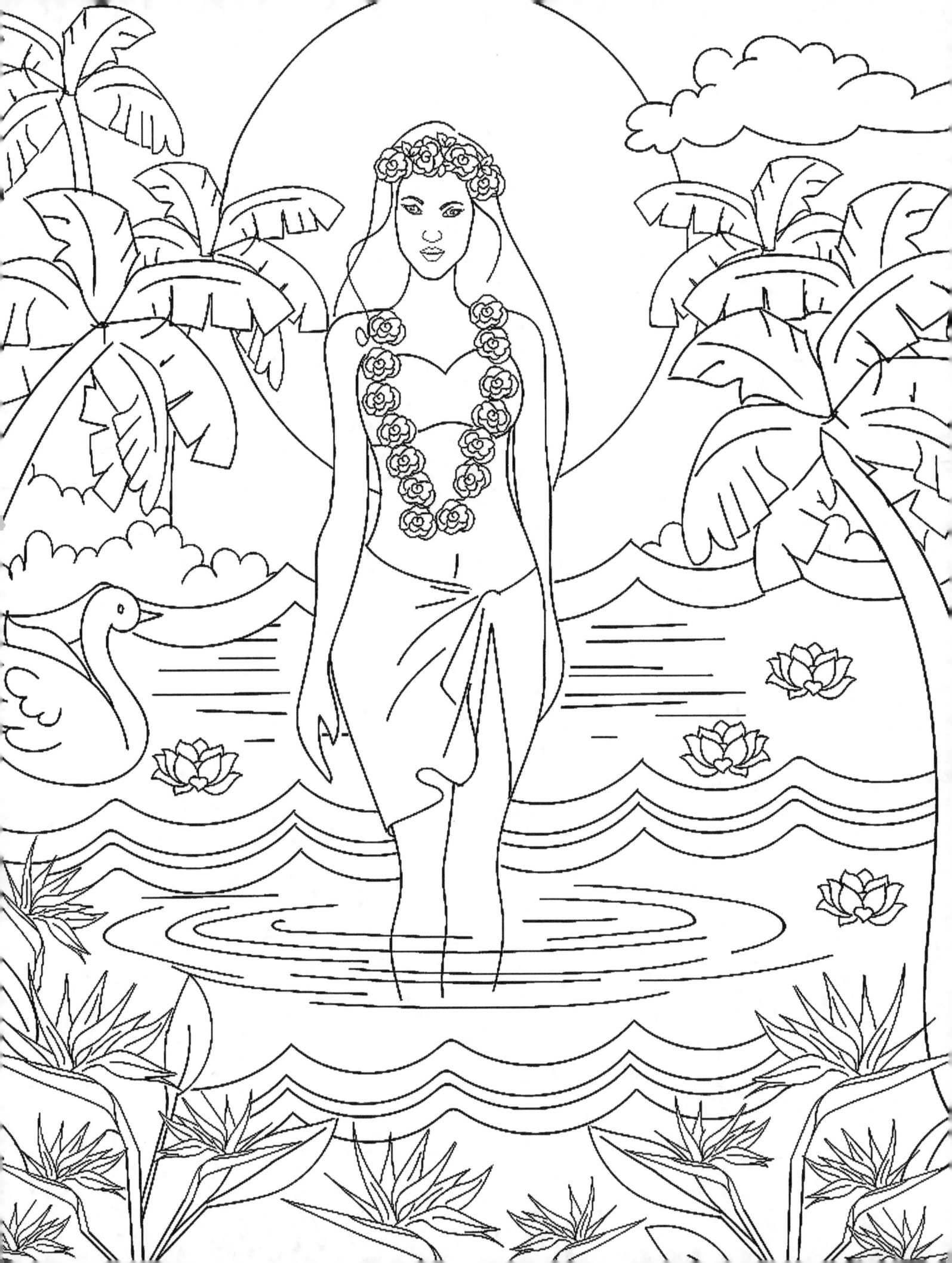

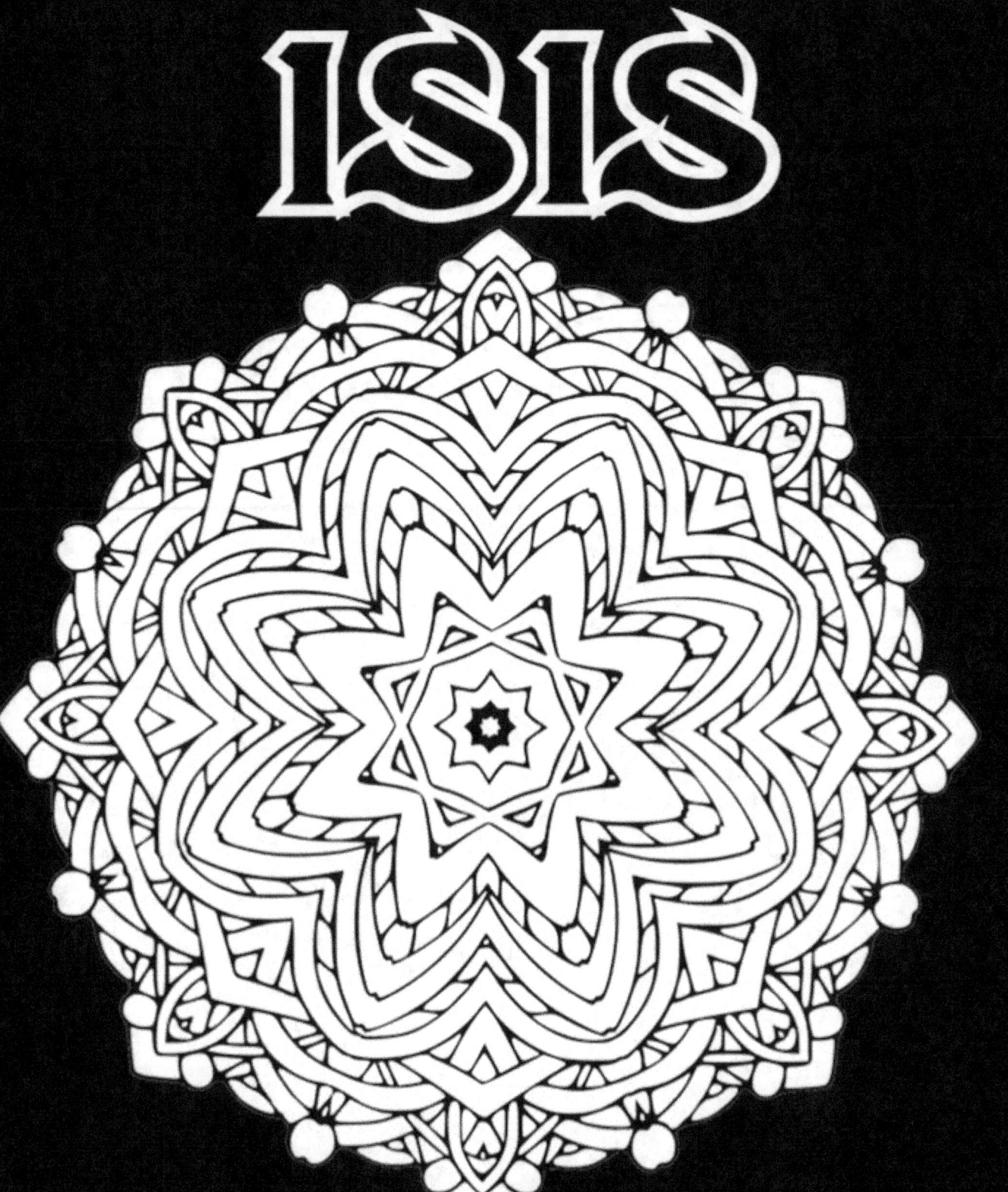

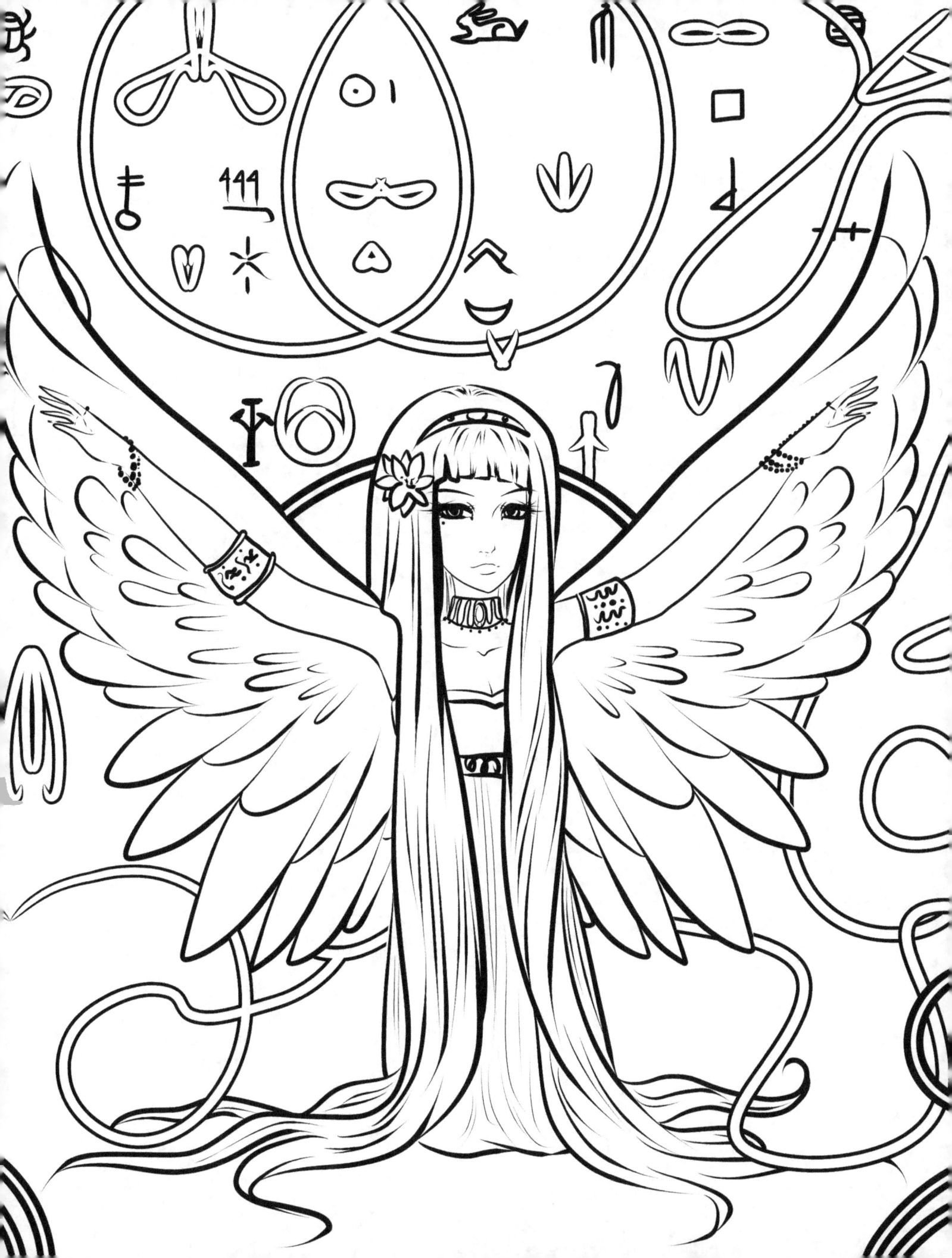

Cut the crap of illusion. Look at your shit and be willing to change.

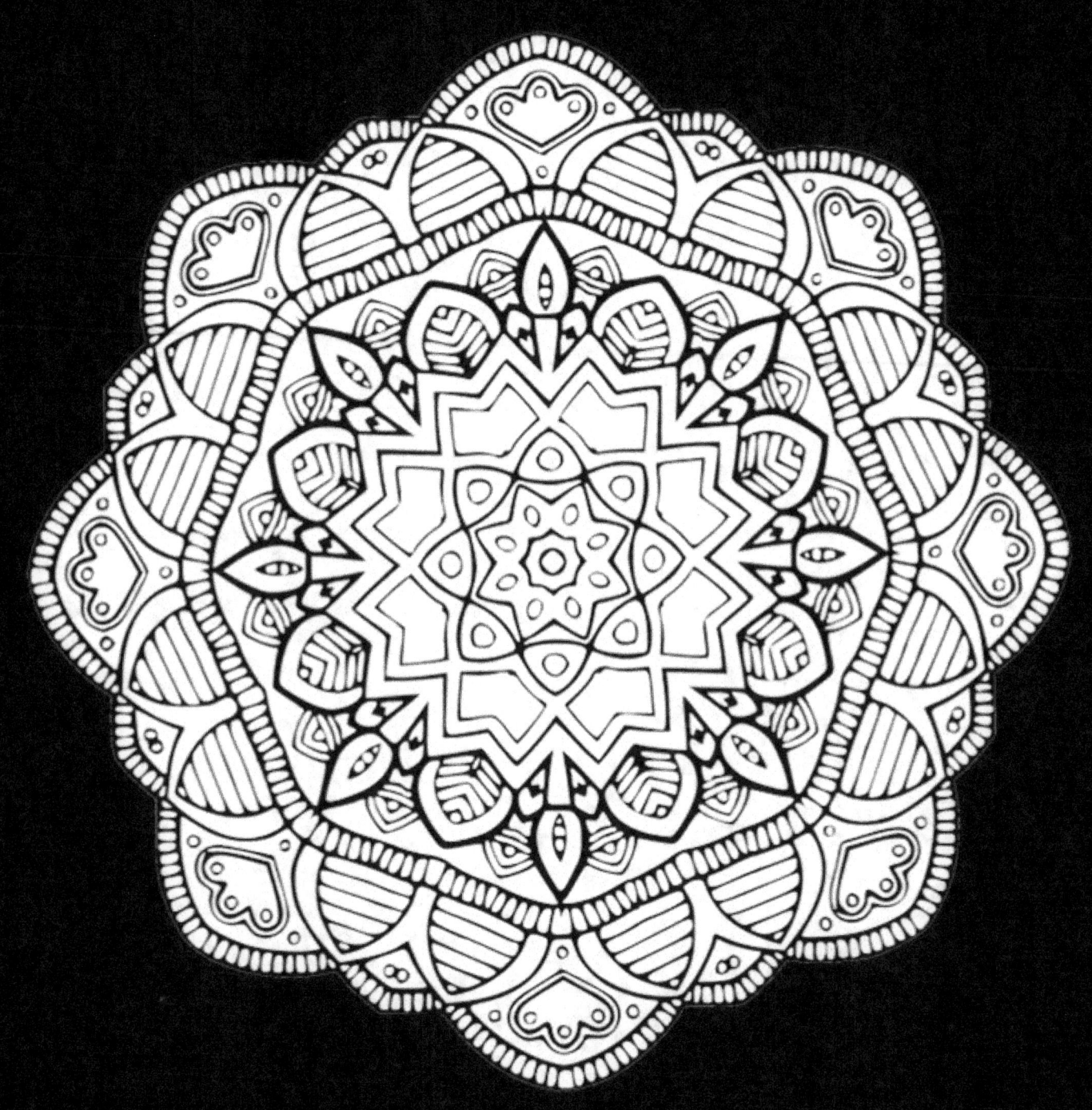

KALI

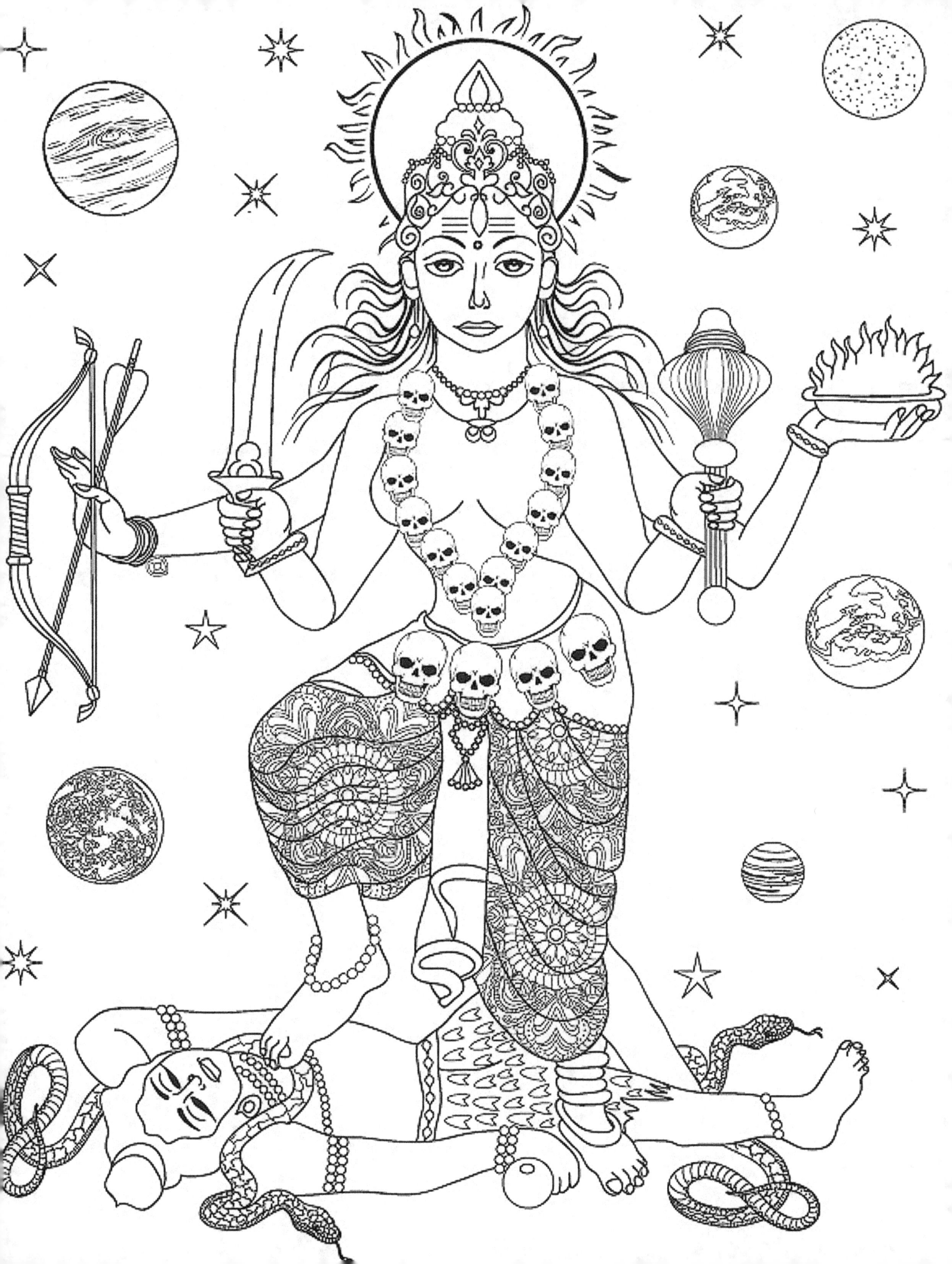

Lady of the Lake

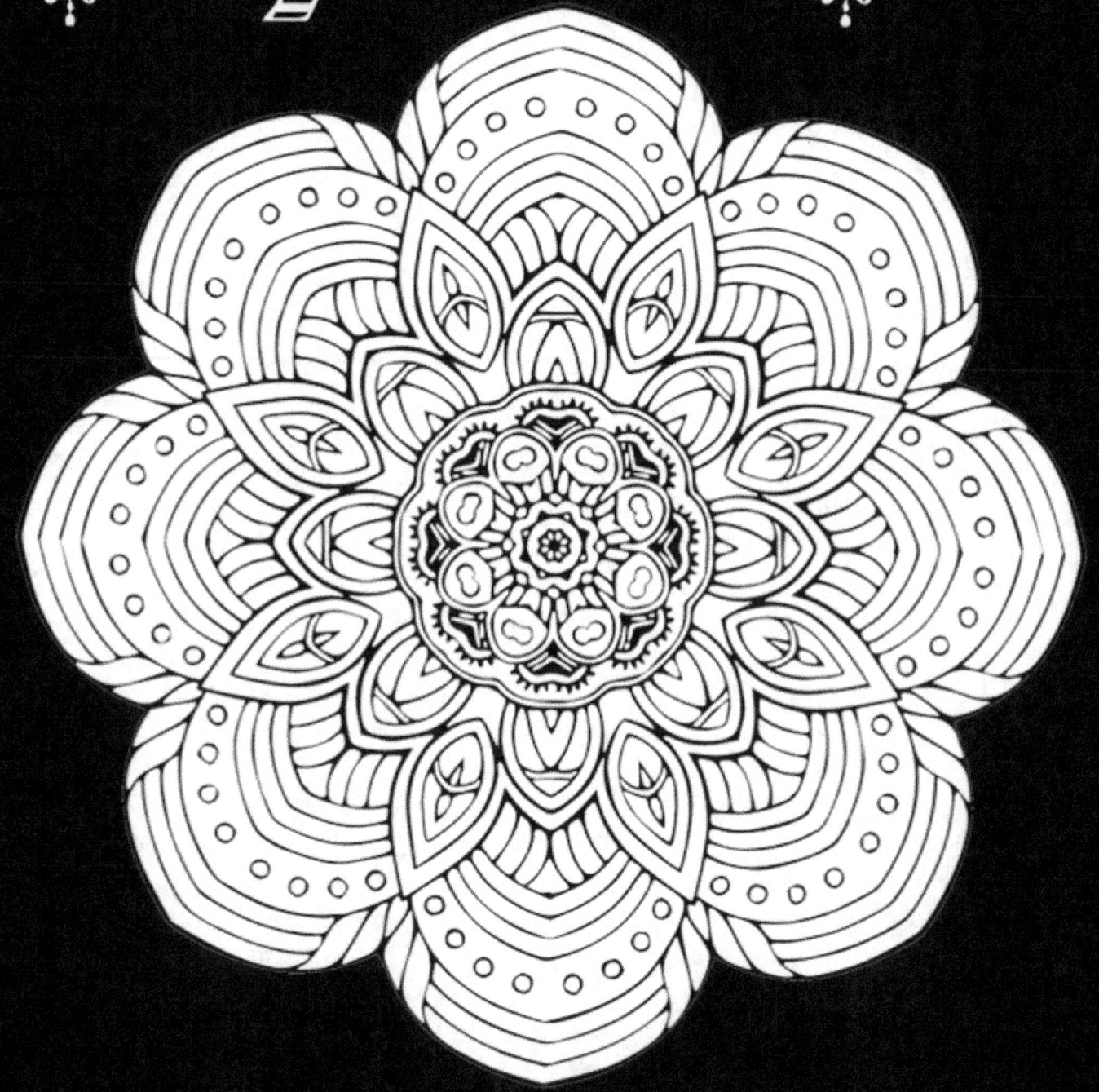

Dive deep into the mystery, cut the superficial, and let go of your bullshit. Be like water; a force subtle yet powerful.

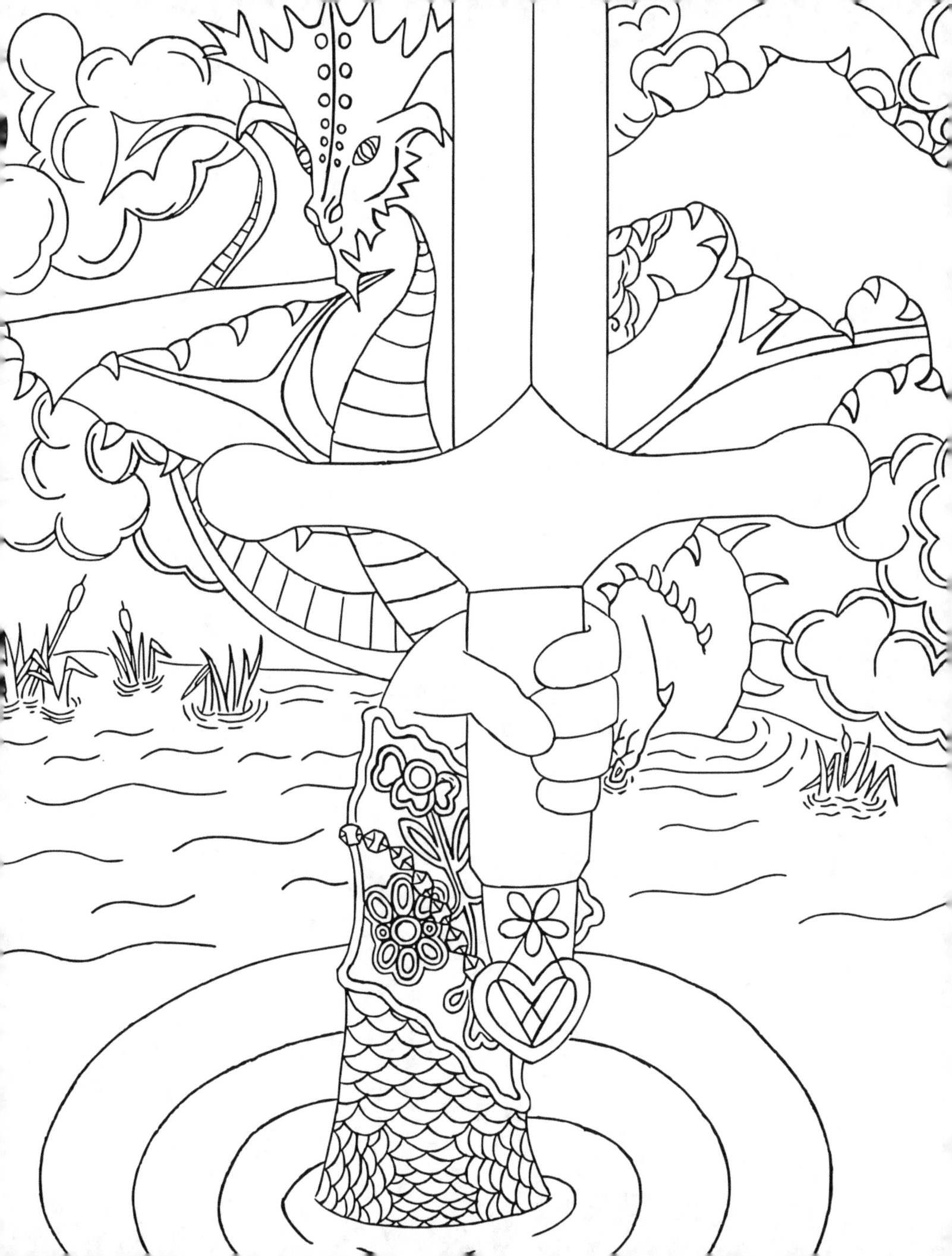

Stand in your power. Be strong and fucking express your passion. This is the key to unlocking personal freedom.

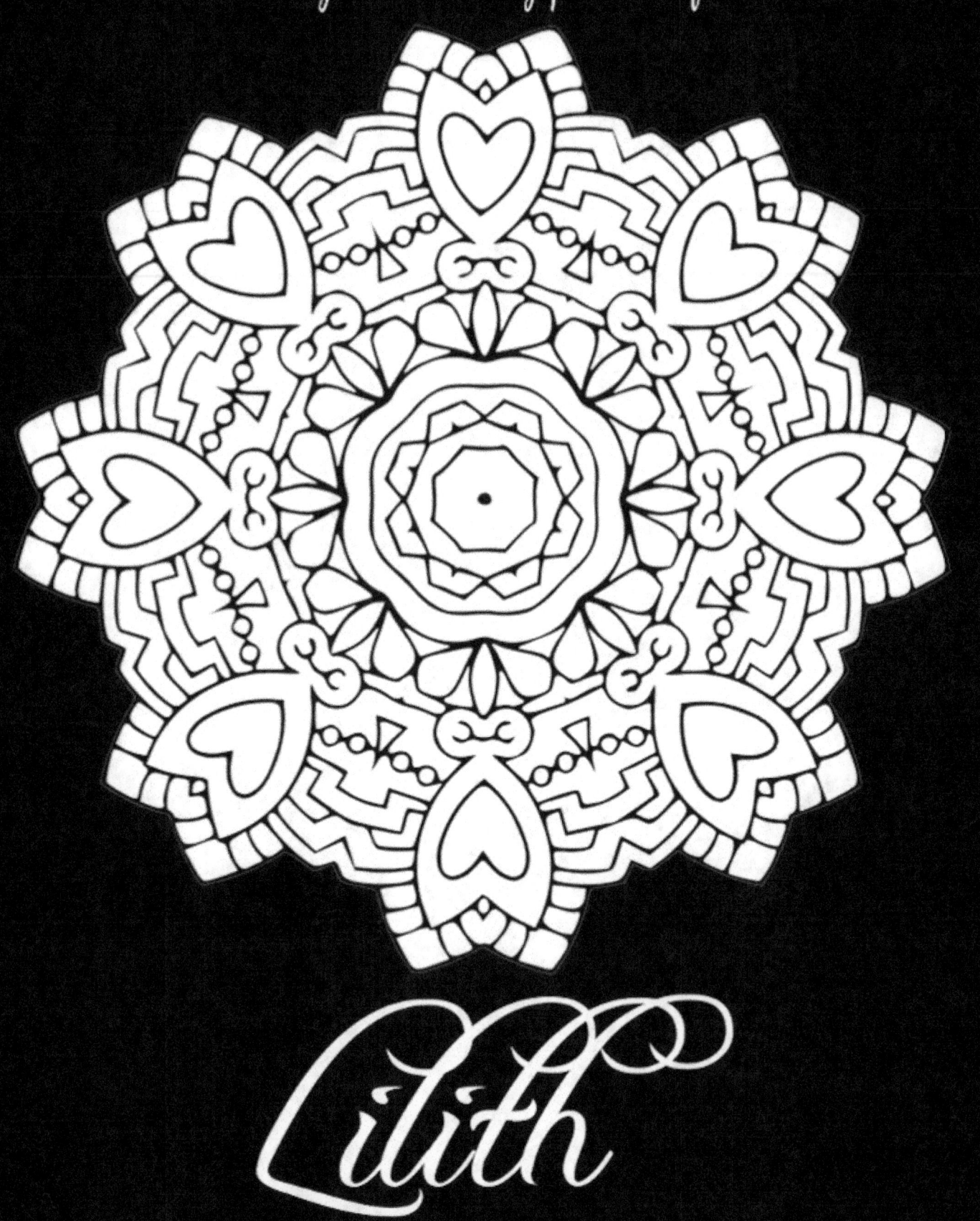

Lilith

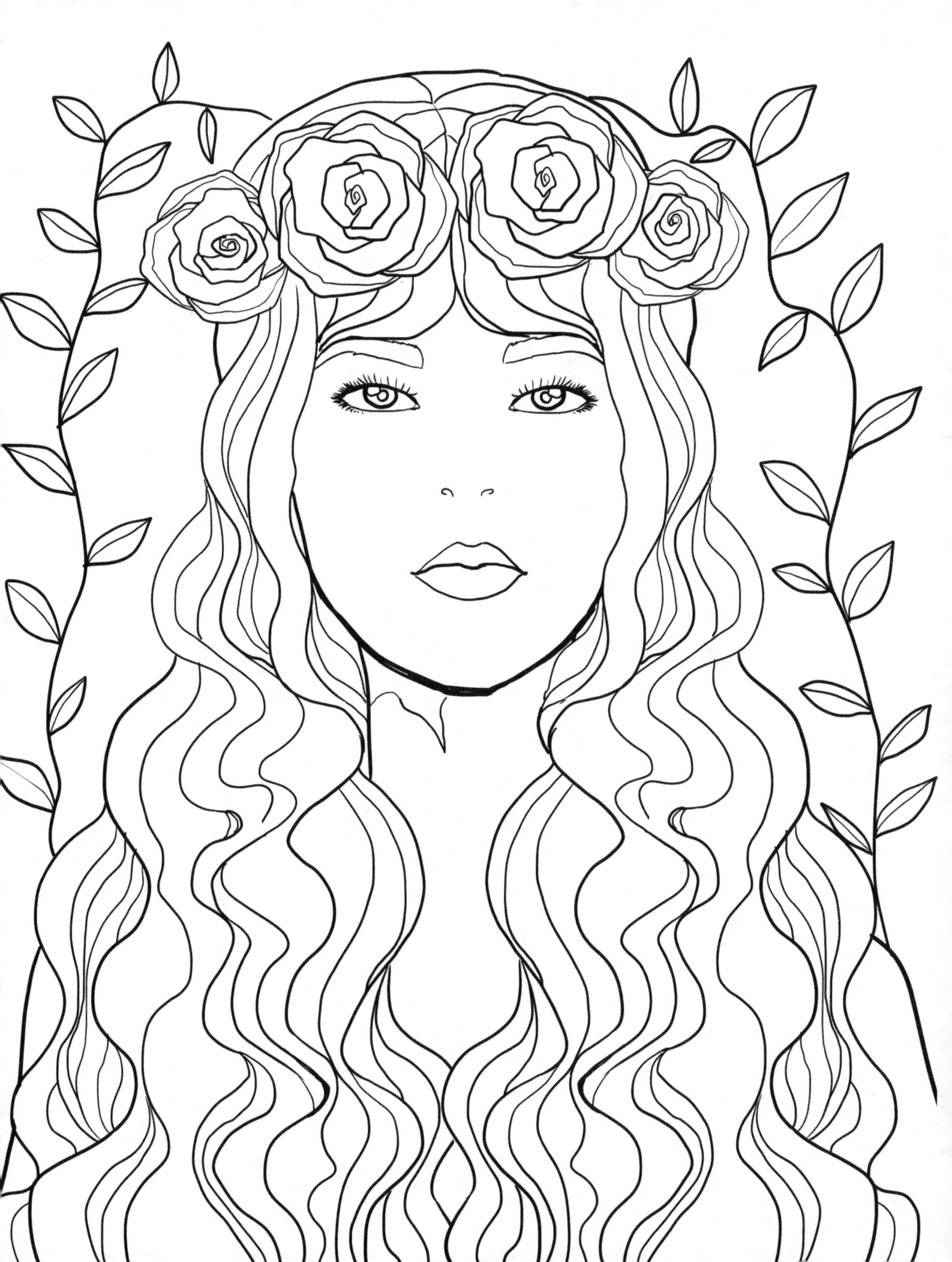

MAMI WATA

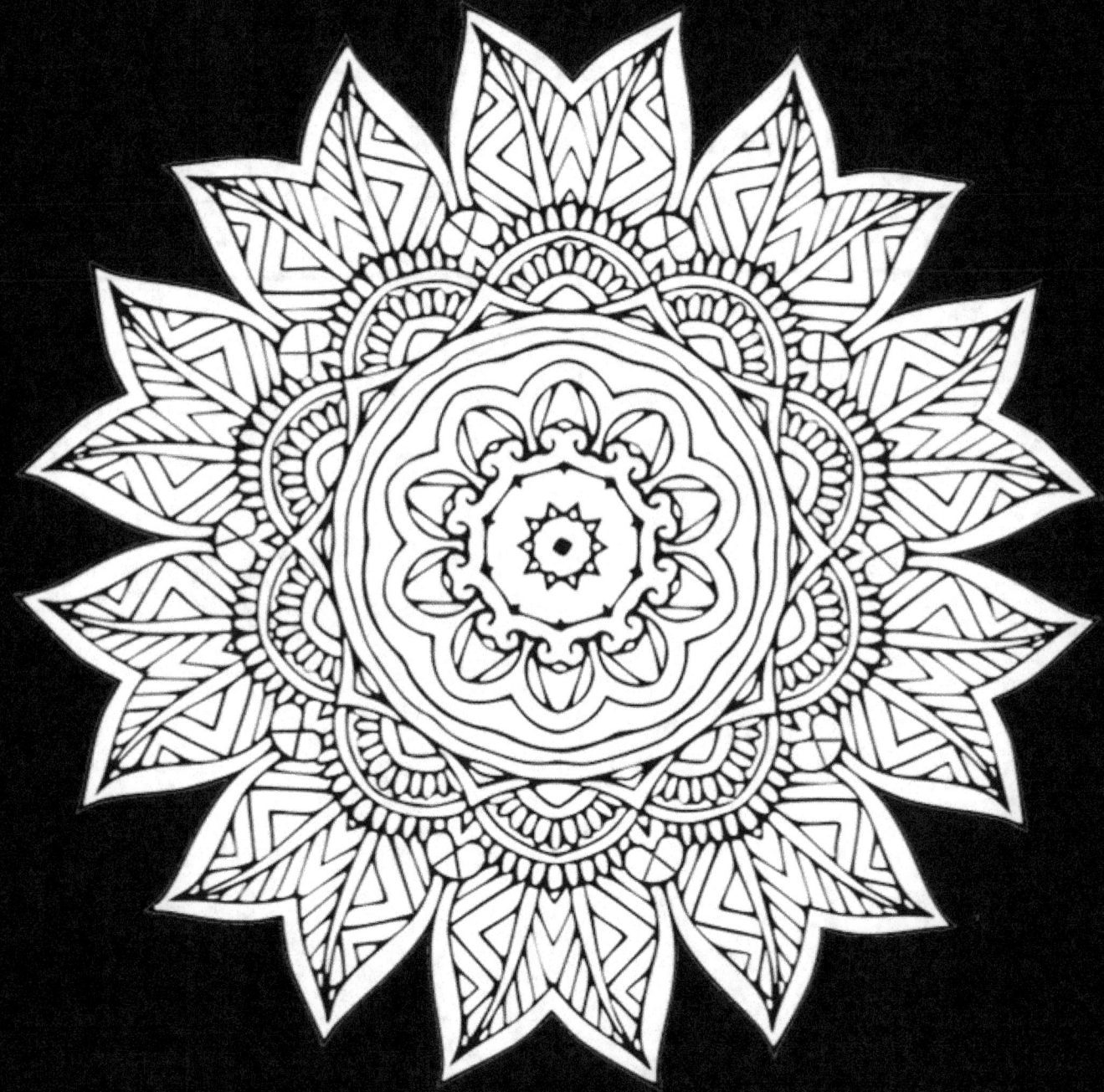

My seduction will captivate you, so fucking surrender to it and riches will come.

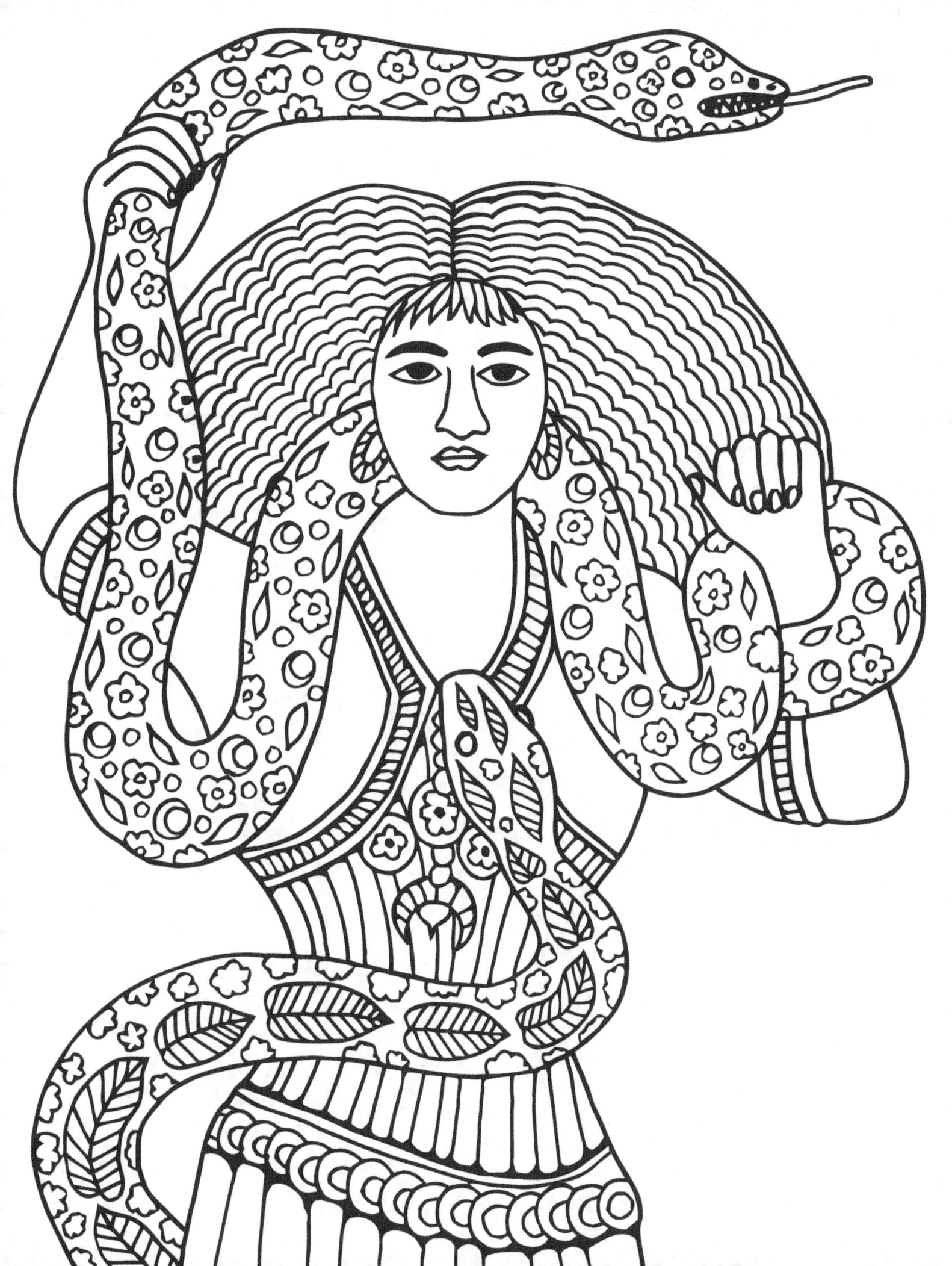

Medusa

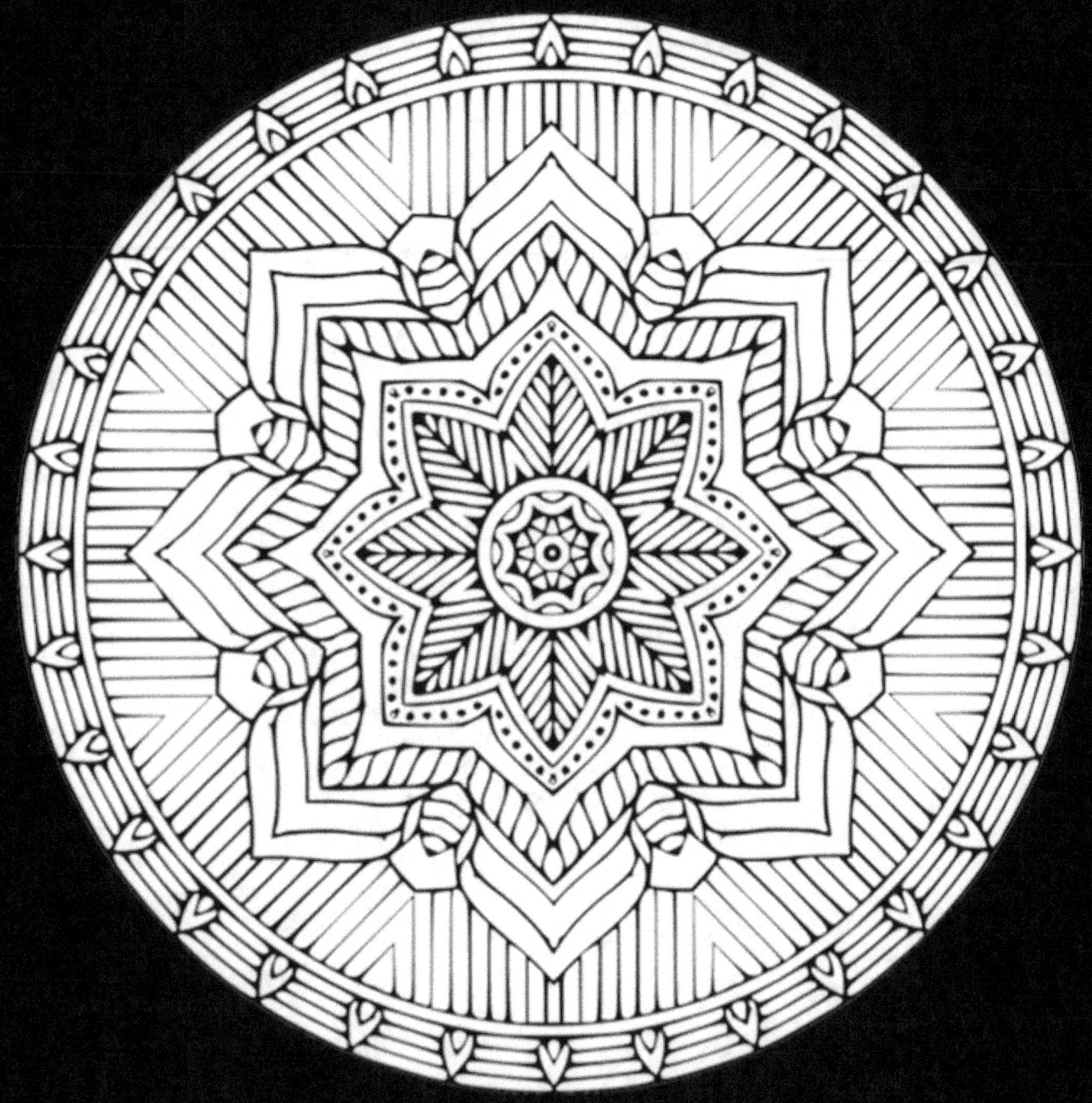

What in you needs to die? My gaze will turn you into stone to face death and be reborn.

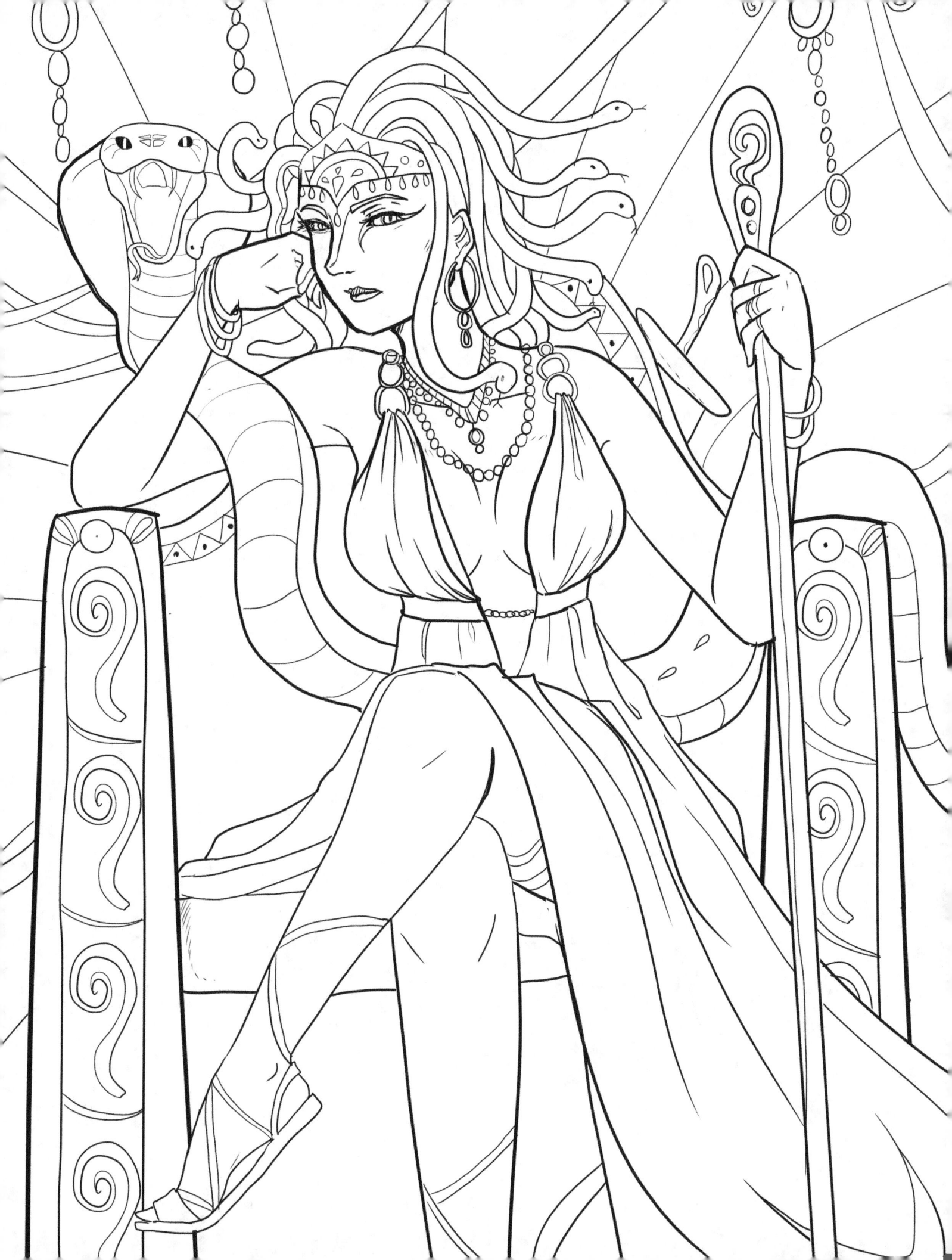

When all shit breaks loose and everything is burning like fucking hell around you, pay attention to the new perspective it's offering. It might be your saving grace.

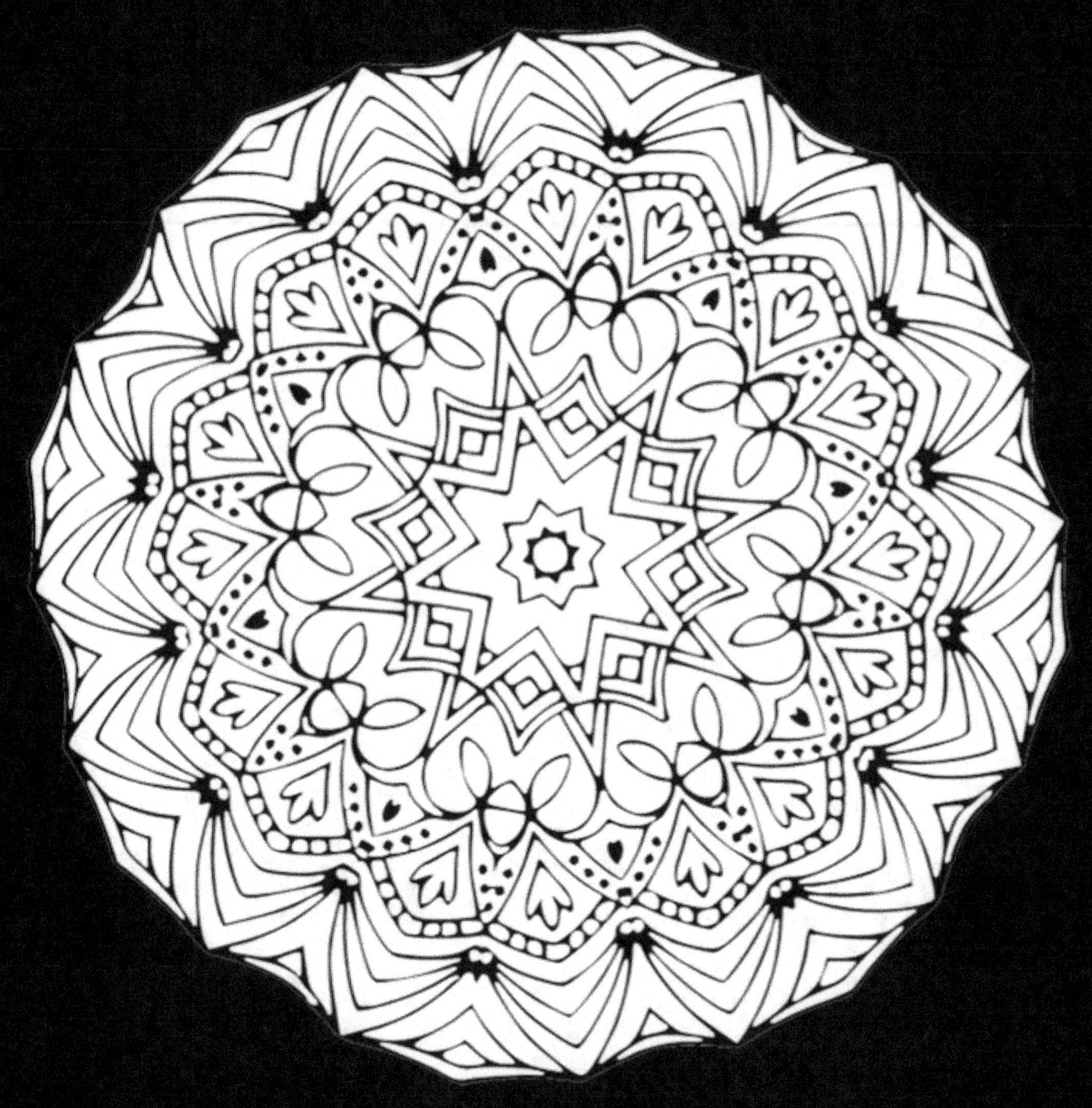

PELE

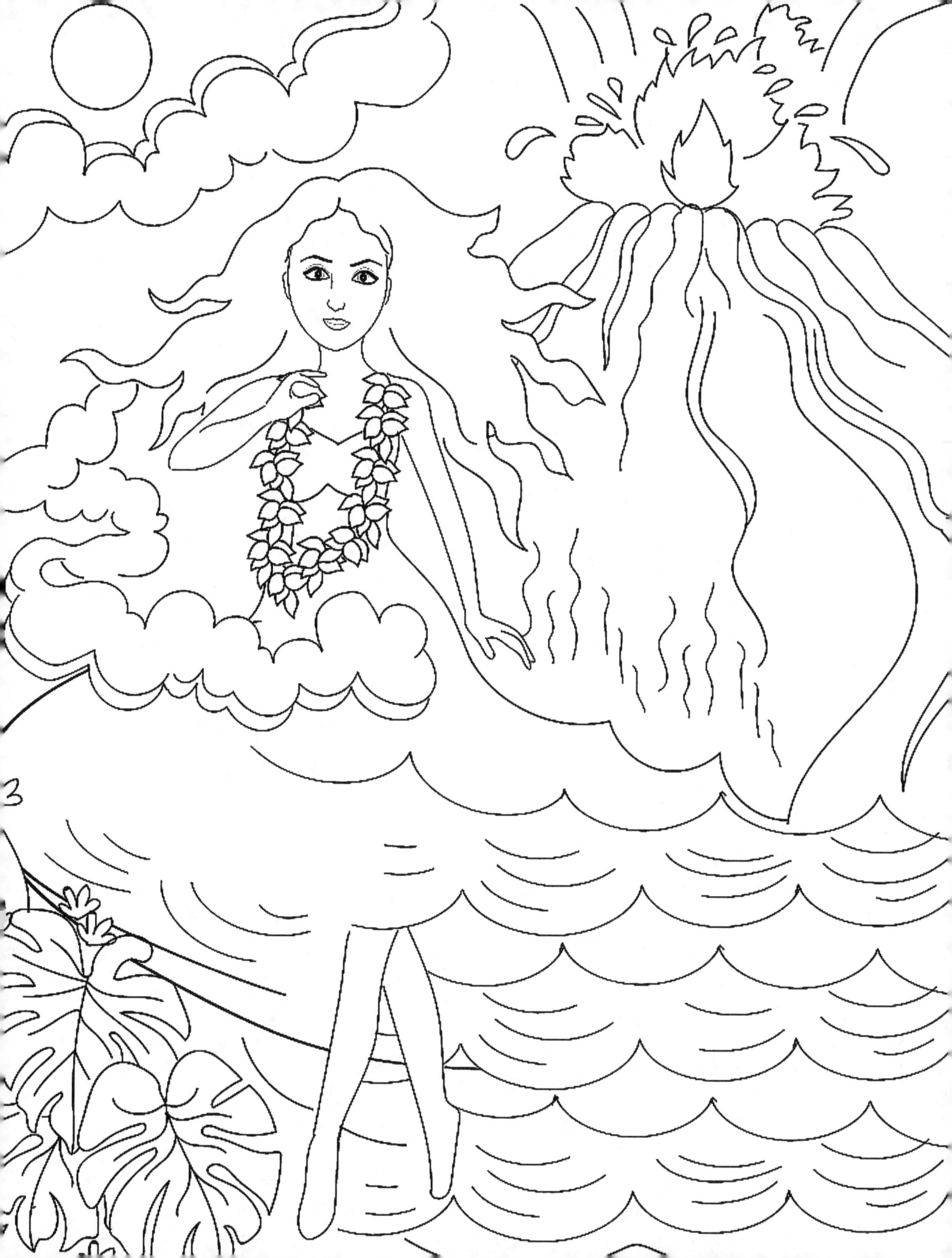

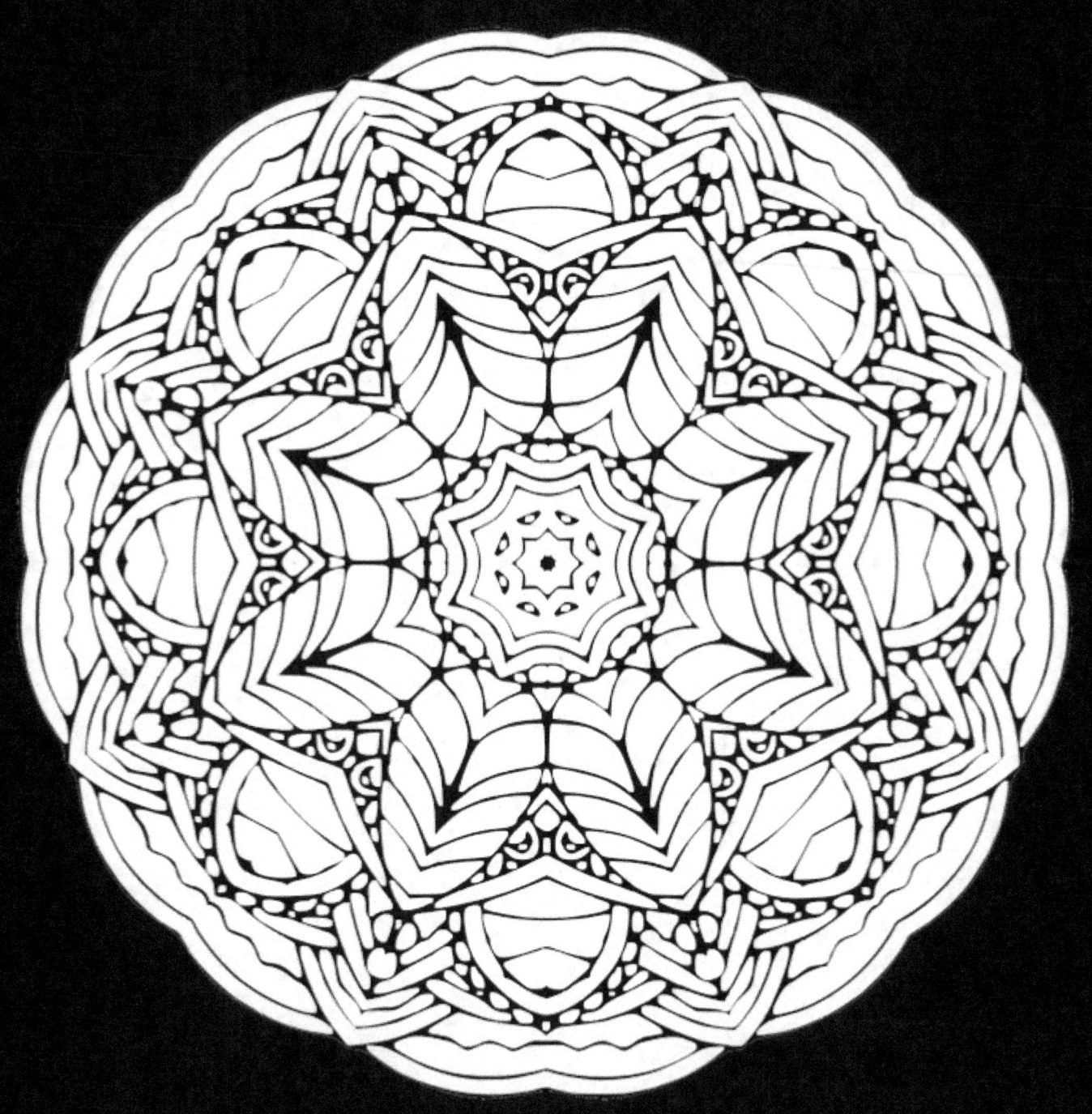

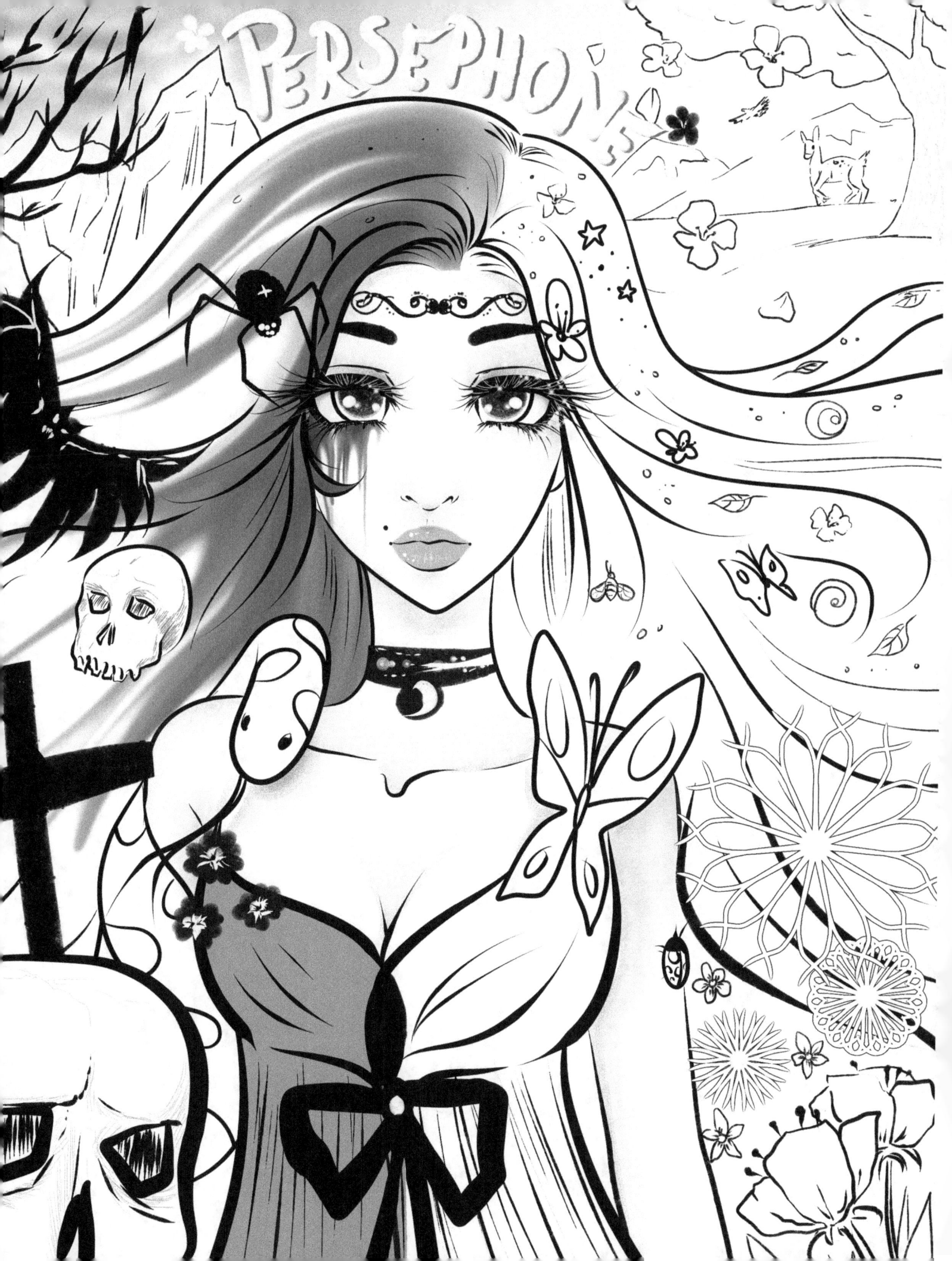

Be the vessel of self love and when it overflows to others, you're giving the greatest gift of all ... damn it!

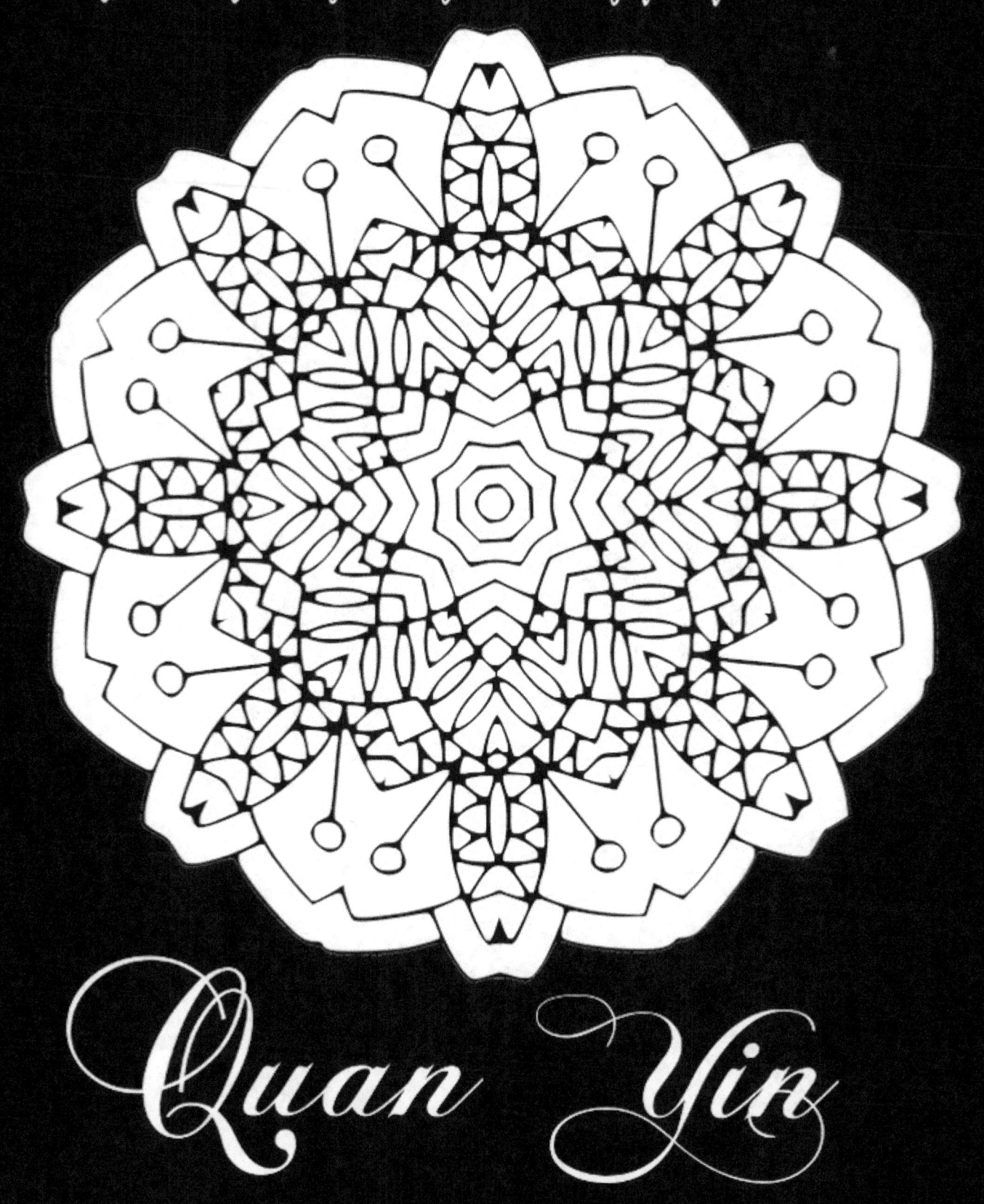

Quan Yin

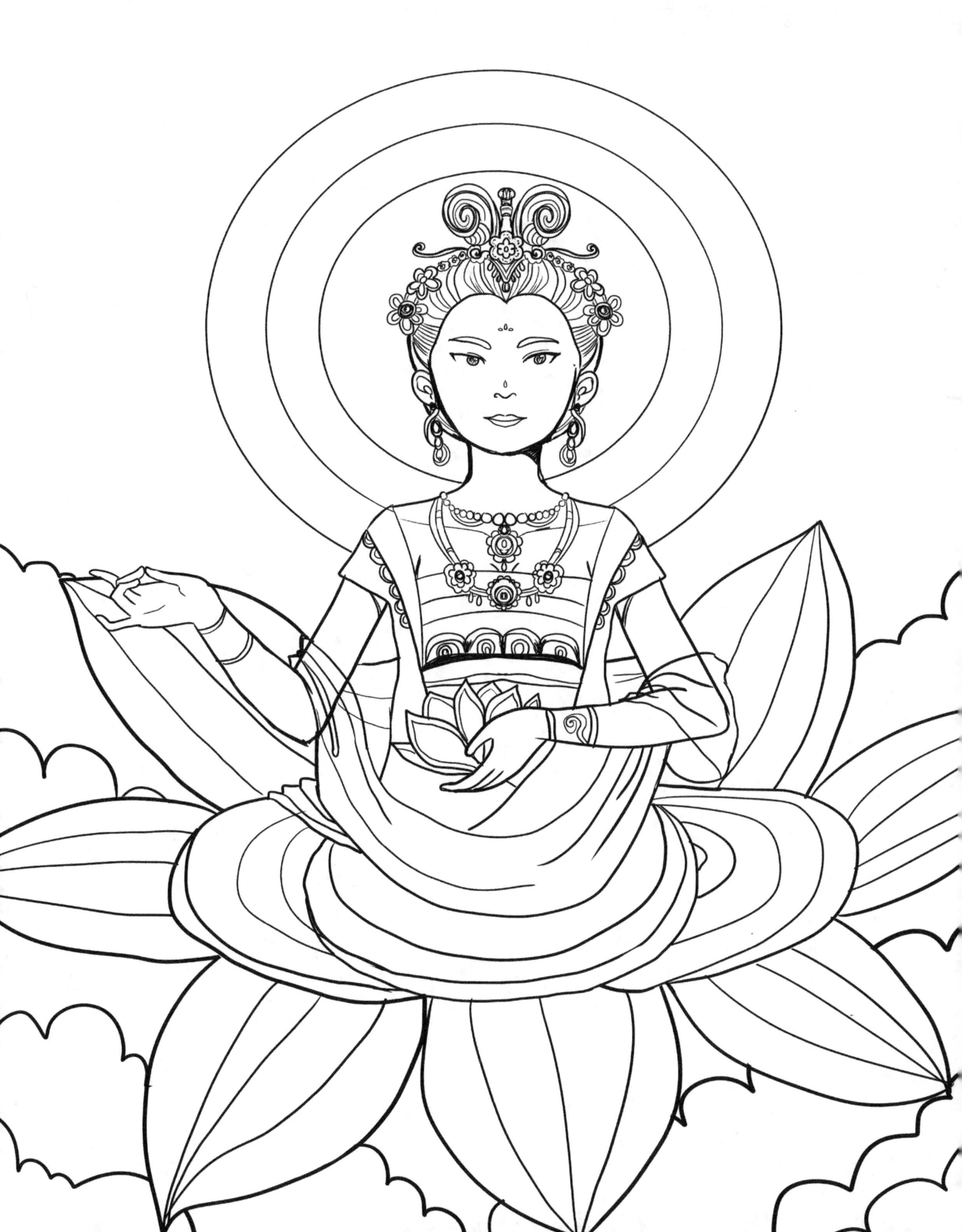

SEDNA

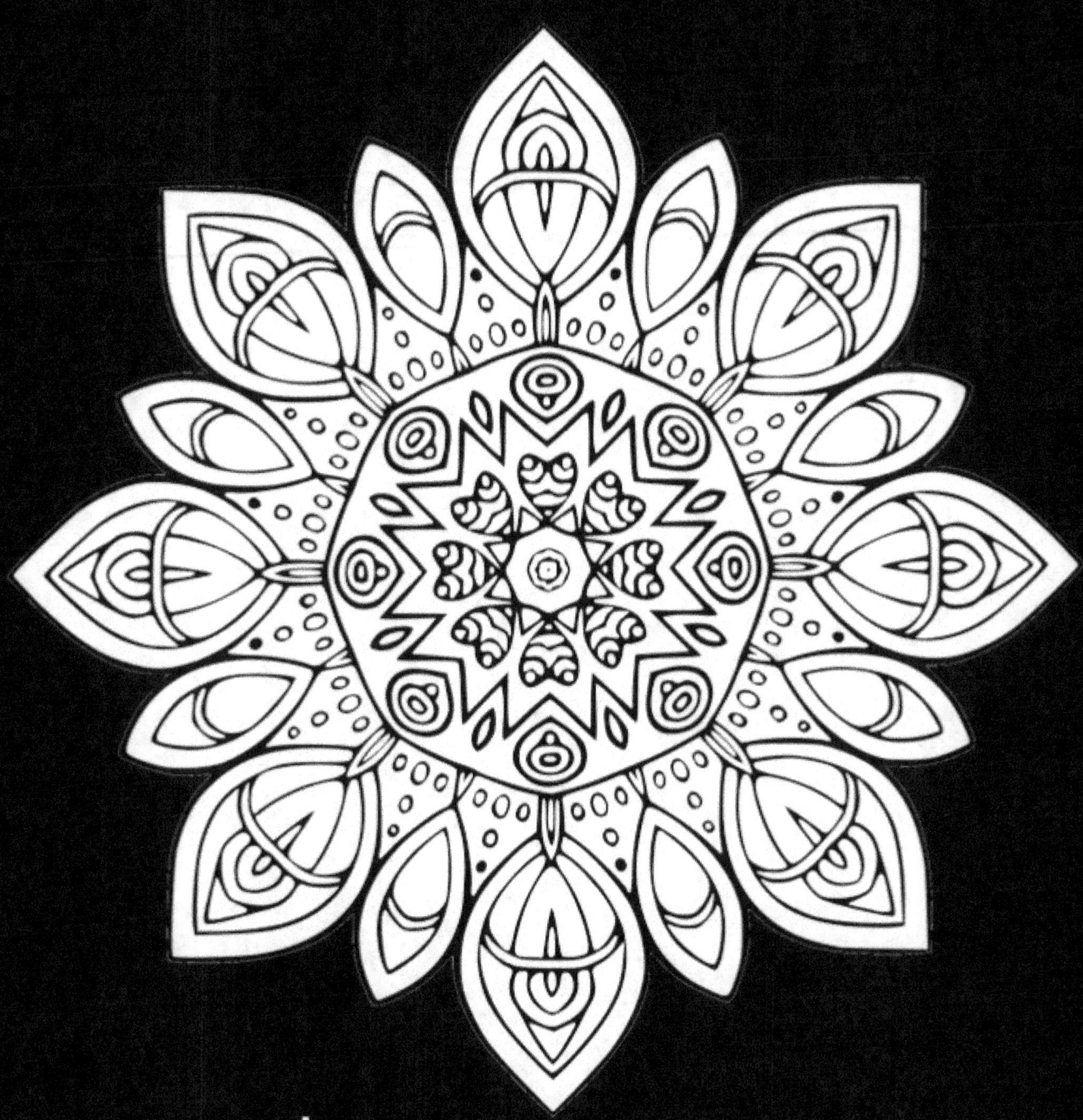

When you're in the deep ocean of misery, struggling for air, remember to slow down, breath and stand in your power.

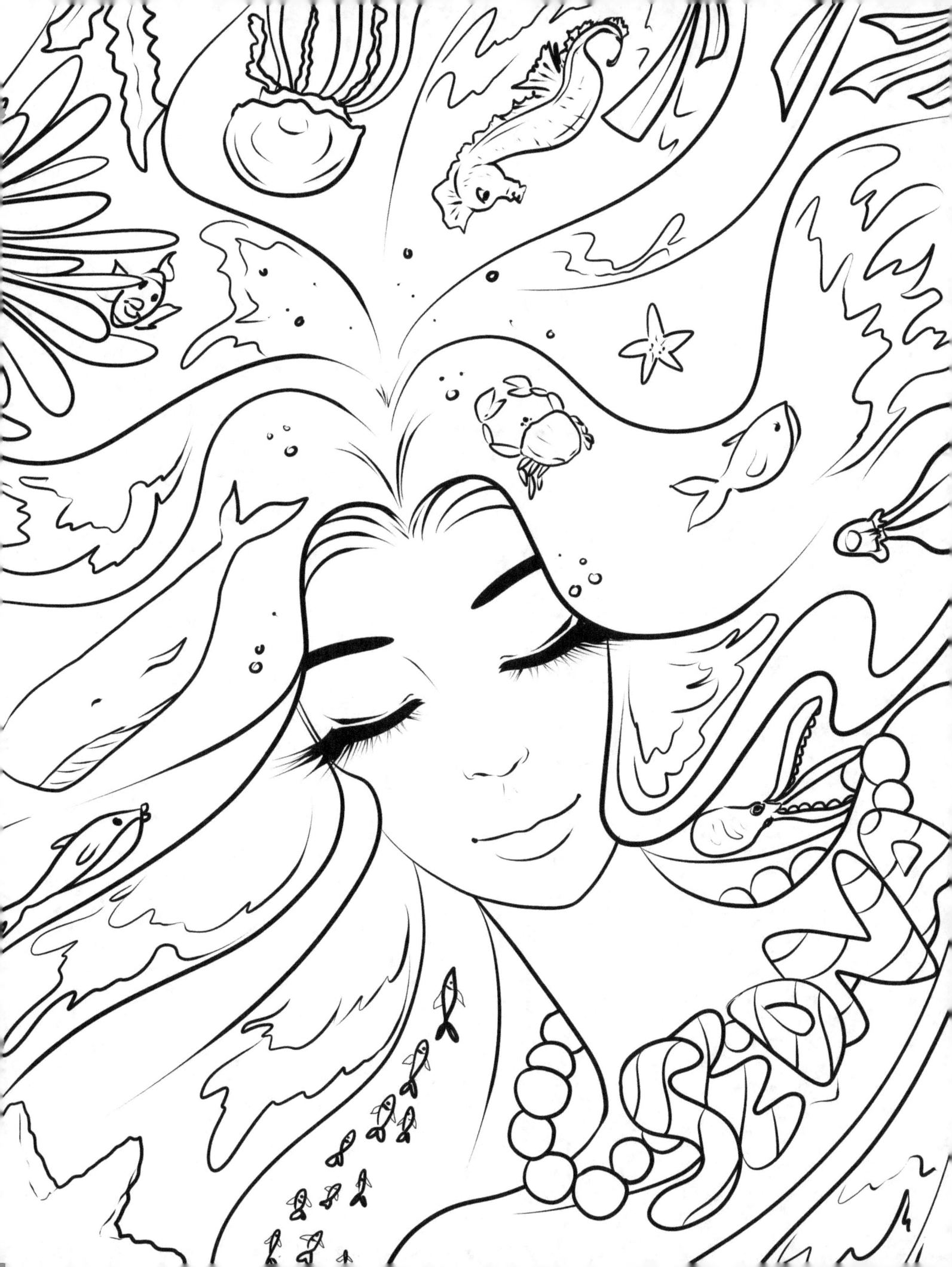

Use your foxiness to adapt and rely on your inner resources.

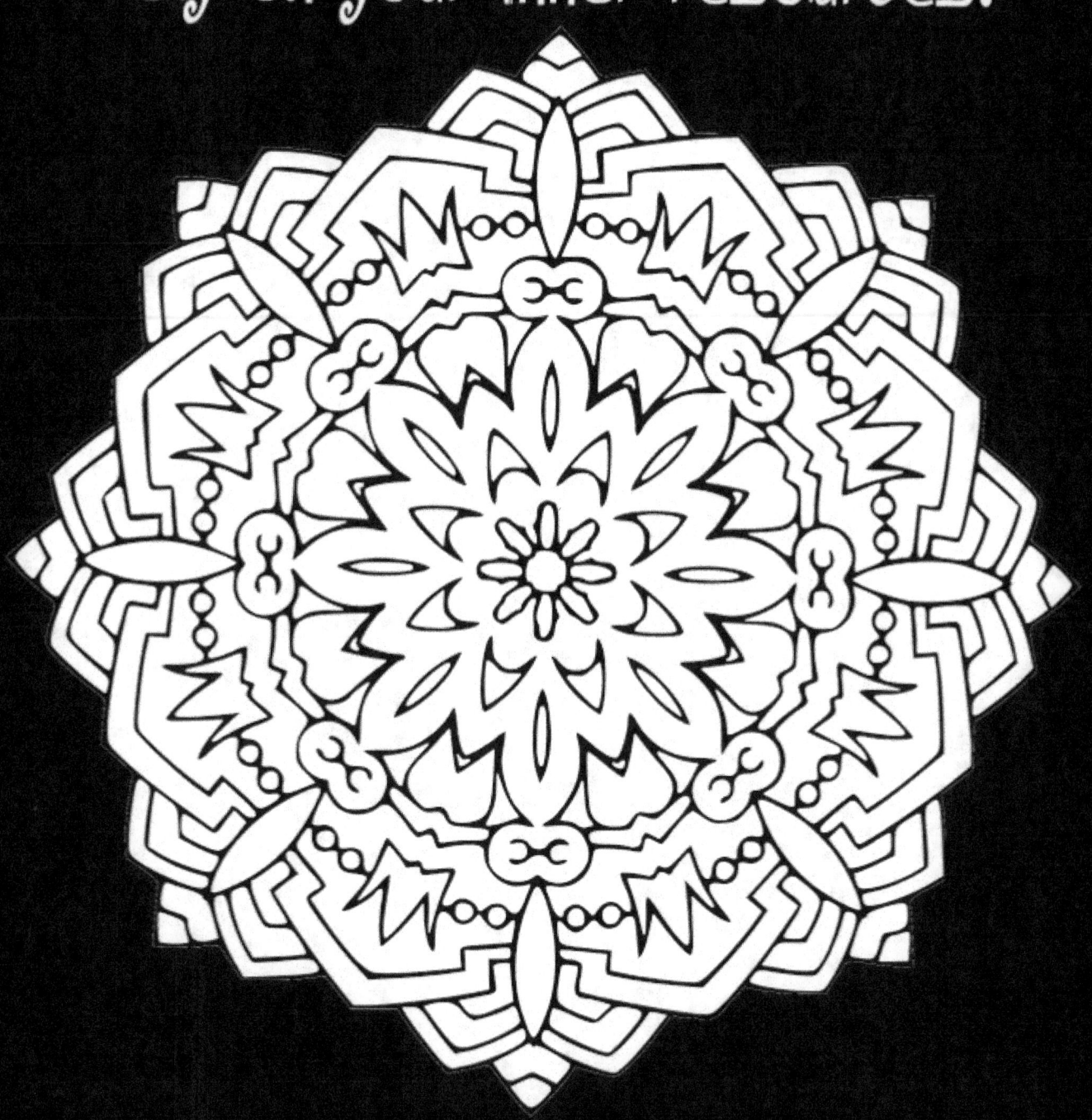

SILVER FOX

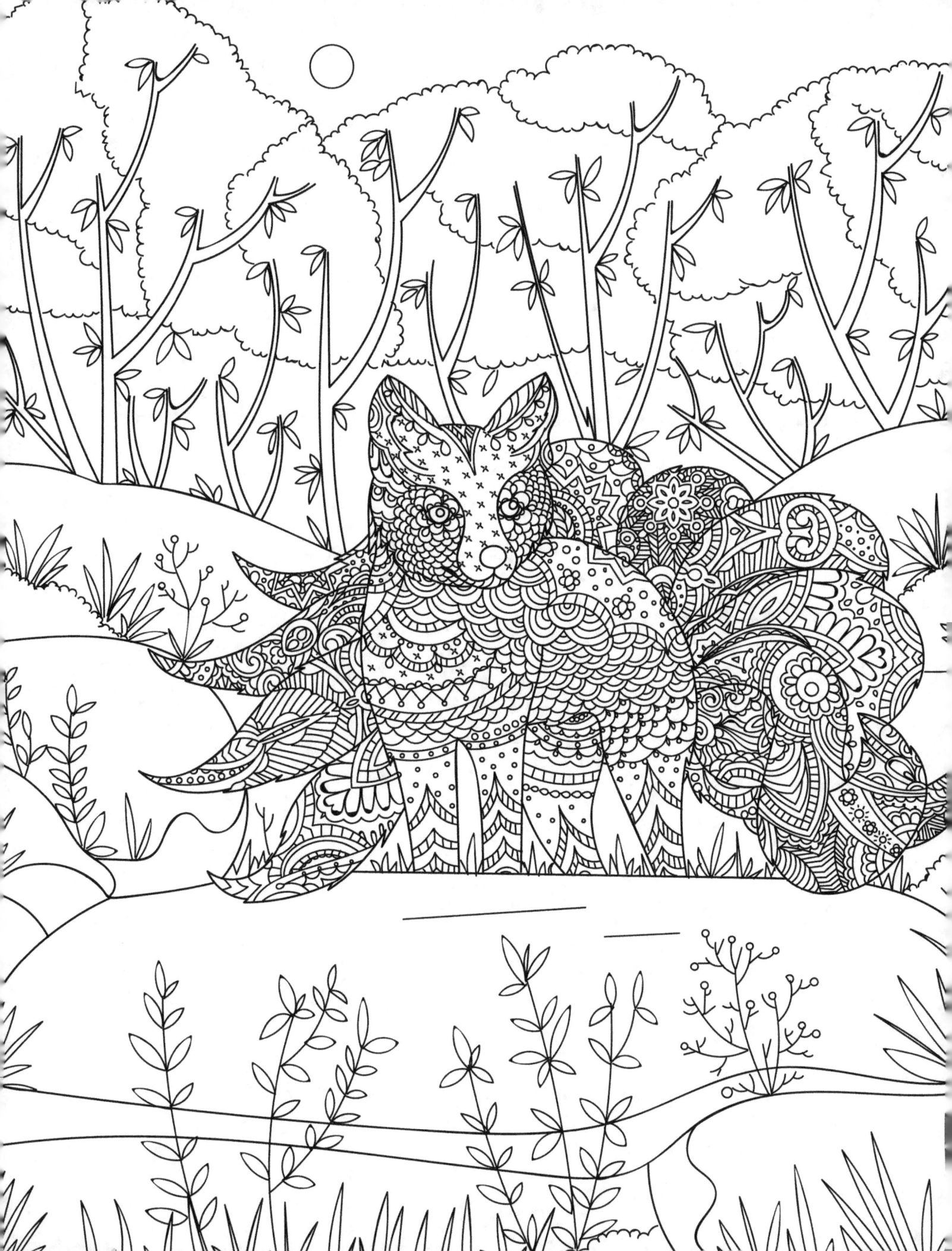

S*K*AD*i*

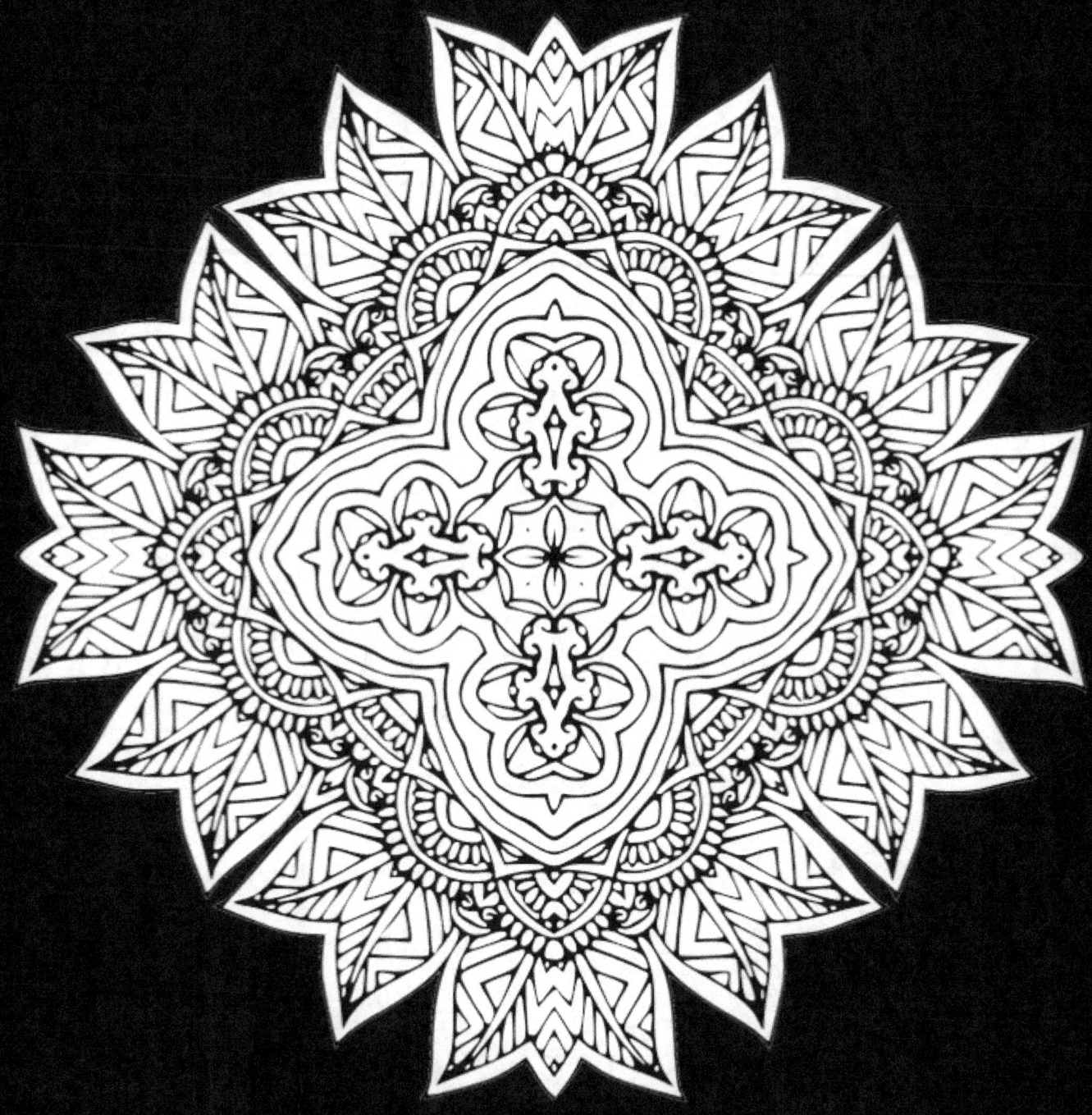

In the kitchen I belong? Lest you remember, that's where the fucking knives are kept.

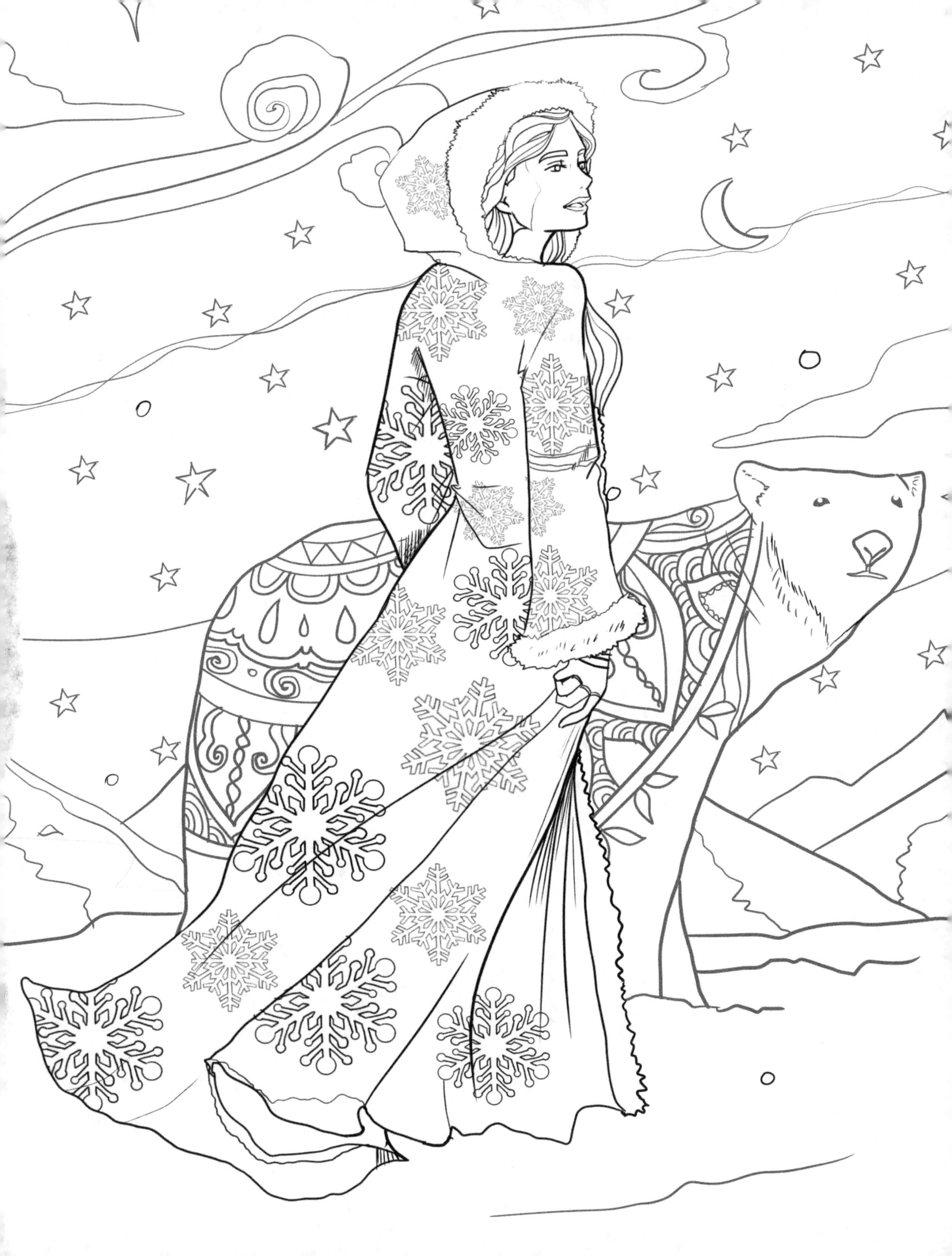

You can't run, you can't hide. Even in the darkest of times, I'm right there to remind you that you can always find your way to the light.

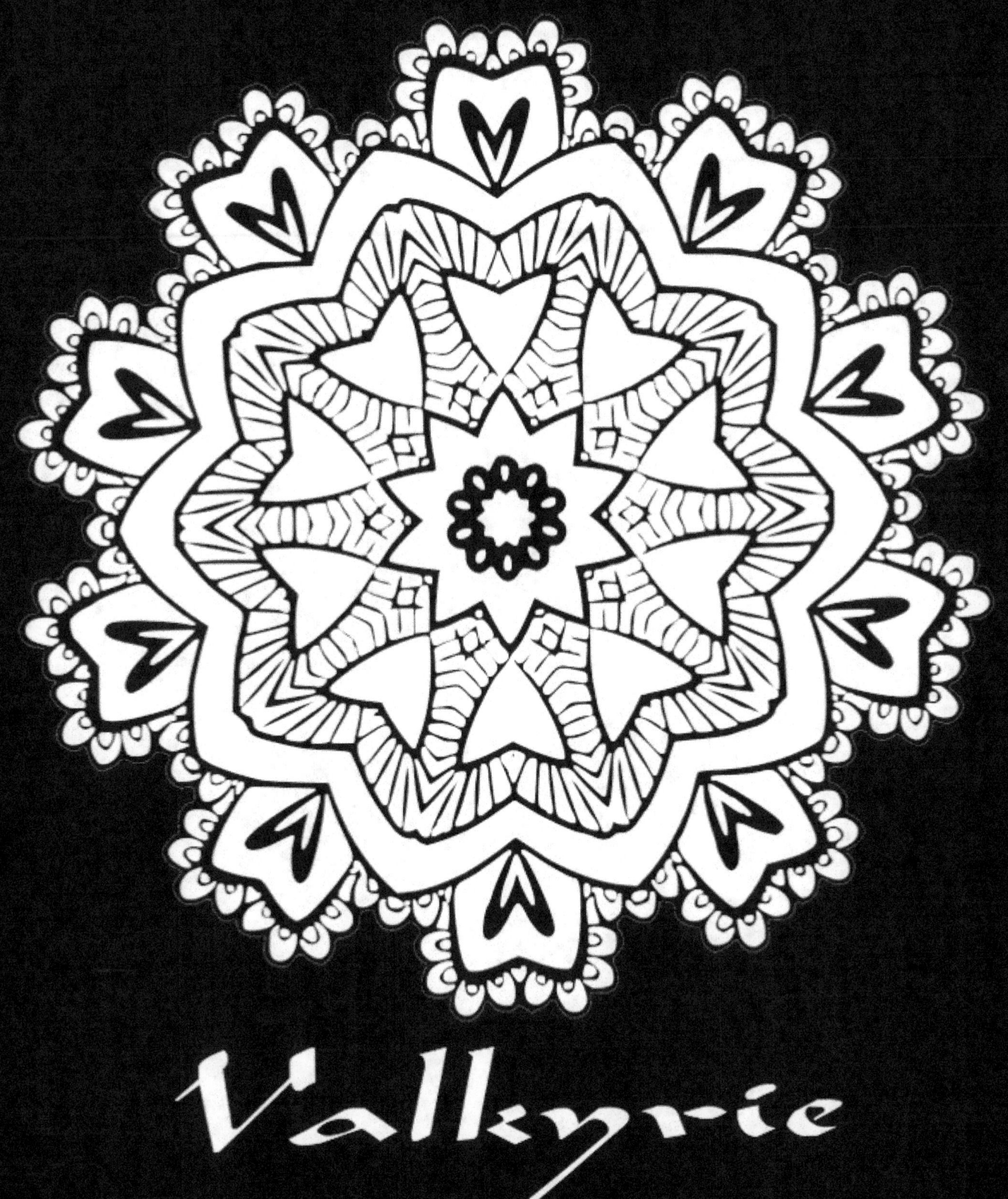

Valkyrie

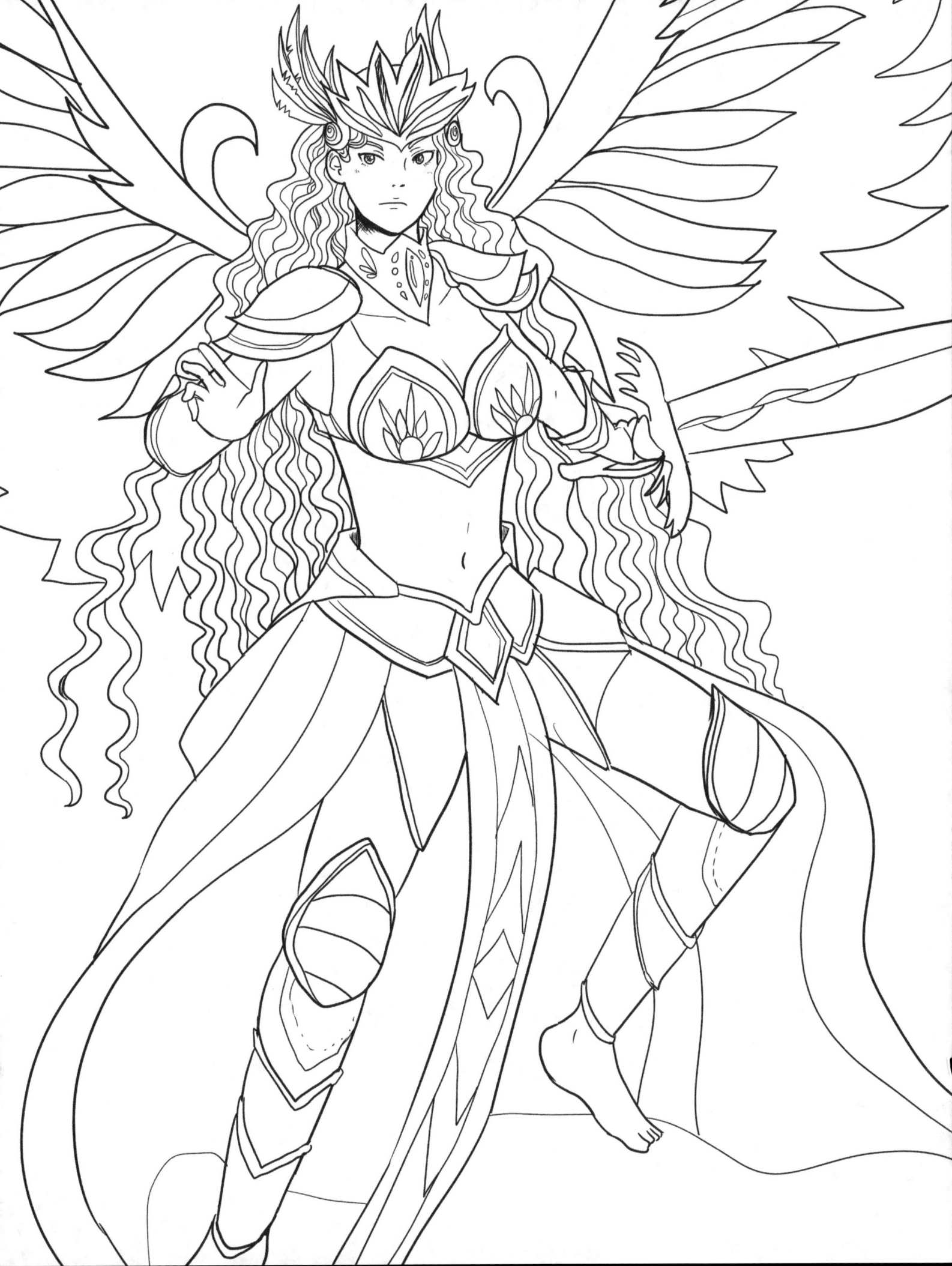

www.ingramcontent.com/pod-product-compliance
Lightning Source LLC
Chambersburg PA
CBHW060014210526
45170CB00018B/2925